Frida Kahlo
An Open Life

Frida Kahlo
An Open Life

Raquel Tibol

Translated by Elinor Randall

University of New Mexico Press
Albuquerque

Originally published as
Frida Kahlo: Una Vida Abierta, © 1983 *Editorial Oasis.*
Translation © 1993 by the University of New Mexico Press.
All rights reserved.
First paperbound printing, 2000

Library of Congress Cataloging-in-Publication Data
Tibol, Raquel,
[Frida Kahlo. English]
Frida Kahlo : an open life / Raquel Tibol ; translated by
Elinor Randall.
p. cm.
Includes bibliographical references and index.
ISBN 0-8263-1418-X (cloth) ISBN 0-8263-2188-7 (pbk.)
1. Kahlo, Frida. 2. Painters—Mexico—Biography. I. Title.
ND259.K33T513 1993
759.972—dc20
[B]

 92-34145
 CIP

Contents

1 Introduction 1

2 Approximations 9

3 Frida by Frida 29

4 Her Years in the Art World 89

5 Her House, Her Things 157

6 Teacher of the Young 177

7 After Her Death 205

Source Note 209

Index 213

I am grateful for the photographs and letters most generously given to me by Isabel Campos, Alejandro Gómez Arias, Henriette Begun, Marco Antonio Campos, Luis Mario Schneider, Ana María Montero de Sánchez, the Coyoacán delegation, and Rolando Arjona, principal of the National School of Painting, Sculpture and Engraving under the Secretariat of Public Education, as well as for the special collaboration of Rodrigo Tinoco, head of photography at this school.

—*Raquel Tibol*

Frida Kahlo
An Open Life

One
Introduction

In the short, unusual, and productive life of Frida Kahlo, the following events stand out as most important. She was born in the town of Coyoacán on 6 July 1907, the same year in which the notable portrait painter Hermenegildo Bustos had died in Purísima del Rincón, Guanajuato. Her grandmother, Isabel Calderón González, entered her in the civil registry, giving her the name Magdalena Carmen Frida. Her father, Guillermo Kahlo, was then thirty-six and her mother, Matilde Calderón, was thirty. By that time her paternal grandparents, Jacobo Enrique Kahlo and Enriqueta Kaufmann, were dead, as was her maternal grandfather, Antonio Calderón, a photographer like her father.

Introduction

At the age of eleven, polio slightly crippled Frida's right leg, leaving it a bit shorter and thinner than the left. She was studying at the National Preparatory School when the first stage of Mexican mural painting was developing. At the age of eighteen, she suffered an extremely serious accident that left her with a profound impairment of the backbone, pelvis, and uterus. She married Diego Rivera at the age of twenty-two when he was forty-two, and from 1930 to 1933 she lived in both the eastern and western parts of the United States. Some time between the Spanish Civil War and the Second World War she met André Breton. The first of her one-woman shows were in New York and Paris, not Mexico. Frida taught at the National School of Painting and Sculpture in the Mexican public school system, and in the cold-war years she was involved as actively as possible in the worldwide contingent of fighters for peace.

The poet Miguel Guardia once wrote of Frida Kahlo that "little could be said; surrealist or not, invalid or not, Frida walked and amused herself like you or me, even if she were suffering at times; she is one of the typical women of our art." Miguel Guardia was correct in observing a vague ambivalence in her person and in her work, but he was mistaken in minimizing her value because of that ambivalence. In addition to being a "typical woman" of Mexican art, Frida Kahlo is a singular human being in the history of culture; her personality could hardly be called simple. Franz Kafka could also be called a "typical man" of Euro-

pean literature, although perhaps it is more useful to consider him as being deeply introspective.

In Frida's work oil paint mixes with the blood of her inner monologue. Her problems, too personal in spite of herself, are framed in an atmosphere like the "court of miracles" Diego Rivera invented to be able to endure himself and to aid others in enduring themselves in the whole breadth of their vitality.

It has been said that Frida Kahlo owes nothing to Diego Rivera, because she never painted the way he did, never thought like him, never talked like him. In a court of miracles no one owes anything to anybody, because one enjoys the privilege of full identity in it. After both met for the first time in the office of the secretary of public education in 1928, Rivera said that Frida made him come down from his scaffold to consult with her about seeing if he thought the paintings she had been doing for about two years were basically salable. She asked him that question more than once. "I'm simply a girl who needs work in order to live." In 1947 a short while after the National Institute of Fine Arts was established, the Department of Creative Arts—of which the painter Julio Castellanos was director at the time—mounted an exhibition of forty-five self-portraits by Mexican painters of the eighteenth to the twentieth centuries, in which Frida participated. For the handsome catalog designed by Gabriel Fernández Ledesma, she wrote with her characteristic sincerity: "I haven't painted

much, and that without the least desire for glory or ambi-
tion, with the determination to give myself pleasure and to
be able to earn my living with my work."

Overcoming countless physical misfortunes, praising life
and making fun of the death that lay in wait for her—and
which at times she sought in trying to commit suicide—
Frida Kahlo succeeded in prolonging her life to the age of
forty-seven. That she lived to the utmost is shown by a
photo of her in a wheelchair as she took part in a demon-
stration to protest the fall of the democratic government of
Jacobo Arbenz in Guatemala, days before her death on
13 July 1954. Full of pain and aware of her premature
decrepitude, she went out to express her disagreement with
imperialism and its lackeys, rather than shutting herself up
to bemoan her enormous personal misfortune.

Off she went in her wheelchair, as if crippled by war—
her leg amputated, her backbone shattered, her flesh emaci-
ated by long confinement and many years of obligatory bed
stays. Recovering from pneumonia and disobeying the doc-
tor's orders, she had no desire to stop adorning her hair with
the many-colored pieces of woolen yarn, as she always liked
to do, and she covered her dark hair with a wrinkled
kerchief. Her characteristic flirtatiousness was restricted to
the many rings her weak fingers were scarcely able to
bear—those strong hands with their thick nails that Diego
Rivera had painted in 1928 in a mural for the Secretariat of
Public Education, distributing guns for the people's revolu-
tion. The same thing seen in the fresco portrait of a twenty-

one-year-old girl and in Frida's gaze in the press reporter's photo of a woman old before her time—eyes spiritually strong and the will to struggle absolute.

Frida Kahlo knew very well the aesthetic and human value of her big eyes crowned by thick eyebrows joined in the middle like the wings of a bird in flight. Painting them dry or raining tears, she always represented them as fixed on the viewer, wide open and defiant. Her face was always serious and thoughtful. Rivera was the one who painted her smiling to commemorate the first anniversary of her death, and in a Mexicanist drawing he shows her as she used to appear before the others: smiling, playful, and vital. She never saw herself like that, not even at the age of thirty-seven, when she painted the miniature *Diego y Frida* (*Diego and Frida*) to celebrate their fifteenth wedding anniversary. Two halves of the face form a single head held up by branches like a nest—his half smiling, her half not. At thirty-seven she had already made the rounds of North American and Mexican hospitals in search of the child her womb would never produce.

Frida and Diego understood and admired each other. They were like two nutritive forces, and they made a love pact in clauses that nobody but they could conceive of or practice. They had no children, and perhaps because of that Frida's face and figure frequently appear in Rivera's murals as a militant, a pre-Hispanic flirt, a revolutionary, or a collector of signatures for peace. But it is the childish Diego, obsessive Diego, Diego broken up and put together again

who is put into Frida's canvases, canvases that are true mosaics, with each grain of color skillfully set like a precious stone. Their spiritual compenetration was profound, complex, and could be said to have been morbid if measured by the hypocritical, repressive, and fashionable parameters of the moral. Their union surely became more intense in the tremendous succession of Rivera's political life-styles in which, in one way or another, Frida was implicated: expulsion from the ranks of the Communist party in the year of their marriage (1929); the rupture with Nelson Rockefeller because Rivera painted Lenin's face on the Rockefeller Center mural in 1933; his association with the United States Trotskyites; the bitter arguments with the Stalinists in the United States as well as in Mexico (1934–35); his joining the Fourth International in 1938; expulsion from the ranks of the Trotskyites because of his support for the reactionary candidacy of General Andrew Almazán in 1939; and finally the clash in San Francisco during Rivera's voluntary exile, which he entered when Siqueiros and a group of his fellow religionists attacked Trotsky's house in Mexico by using a small truck owned by Rivera.

Now that there were no more political storms to segregate Rivera in a certain sense from the Mexican cultural medium, Frida and Diego settled themselves more firmly into their respective tasks and struggled with real fervor against Nazism and on behalf of the Soviet Union in the Second World War years, and after it ended and during the

cold war, in behalf of a peace that would guarantee national sovereignty and economic freedom.

We must note the fact that Rivera never placed Frida among the surrealists. Aside from everything else, there are irrefutable proofs to show that Frida did express herself within surrealism before she met André Breton and before she traveled to Paris. This was shown by almost all the drawings and paintings made before 1938, the year when Breton received her into his kingdom by writing the article "Frida Kahlo de Rivera," which, after being published in different magazines, appears in the corrected and enlarged edition of *Le Surréalisme et la peinture* ("Surrealism and Painting"), Gallimard, Paris, 1965. Rivera always preferred to emphasize her peculiarities. In 1953 he spoke to me about her "mutilated beauty" and stated: "It isn't tragedy that governs Frida's work, as has been wrongly believed by many people. The darkness of her pain is merely a velvety background for the marvelous light of her biological strength, her superfine sensitivity, shining intelligence, and invincible strength to struggle for just being alive, and for teaching her comrades, human beings, how to resist the opposing forces and triumph over them to reach a higher joy, against which nothing will prevail in the world of the future, where the collective value of life as a whole will make the true and really human historic period of our society appear."

Two

Approximations

What was Frida like? She was a tremendously powerful reactor who constantly spoke her mind. She knew the deepest vivacity of what we call enthusiasm, and needed the exaltation that is braided into love, joy, and truth. She decorated truth, invented it, shredded it, drew it out and provoked it, but she never misrepresented it. She was credulous—believed in people, in their word, their history, their possibilities, their dreams, and their quality. She was suspicious, suspicious of their passions, hatreds, and peculiarities. She made of herself an object of admiration. If there was vanity, caprice, or insolence in that, it was never foolish or arrogant, and she did not know humility because

she did not know resignation. Frida was a definitive para-
dox that exemplified the power of rebellion in the face of
destiny, that of an attitudinal triumph, of the beauty of
being conscious, of will shot like an arrow at an adverse
destiny.

Due to the slight physical defect resulting from polio, the
Coyoacán children made fun of Frida, and to overcome the
suffering caused by these taunts she showed off by doing
some real acrobatic tricks on her rented bicycle and skates in
the streets and gardens. Slim, agile, and somewhat boyish,
she enjoyed climbing trees and jumping over fences. Over-
coming her inhibitions, she extended her range of games
and adventures. Since she would often accompany her fa-
ther to help him load his cameras and aid him during his
epilepsy attacks, she knew the city quite well, but it was her
entrance into the National Preparatory School in San Ilde-
fonso that placed her in the old student neighborhood, one
she was not to enjoy as much as she would have liked. Her
intelligence, vivacity, and vocation for medicine—a career
that very few women entered in those days—won her
affection among the students. She knew she did not pass
unnoticed in the growing exuberance of the preparatory
students. It was a time when reaction was starting to mobi-
lize the students to act as shock troops against the muralists.
Of course Frida did not close ranks with those who slan-
dered the decorations of the old patios and the new amphi-
theater. She loved painting. Her father had taught her to see
artistic value in church ornamentation, and from the time

she was very small she had learned how to manage paint brushes and draw copies of well-known prints; until she came to take some classes in the workshop of the engraver Fernando Fernández. Drawing was first of all a cultural supplement like German, which she studied to make her father happy. She would start with this rudimentary knowledge when she thought about making painting a way to earn a living.

Frida invented a life-style in which toys had a place: dolls asleep in lacquered boxes and skeletons hanging from ceilings, walls, and furniture—big skeletons clothed in popular dress and little skeletons in all the corners of the bed where Frida protested her horrible suffering and where she arranged a grand procession of jewels, glass balls, embroidered costumes, and flashy hairdos.

In 1946 the German physician Henriette Begun, in Mexico since 1942, wrote Frida Kahlo's clinical history:

Frida Kahlo: Born 7 July 1910. (Frida started to use this wrong date from the years of her adolescent engagement to Alejandro Gómez Arias, who was a year younger than she.) Parents dead. Father German, mother Mexican.

Father: Epileptic attacks since age of nine, apparent cause injury from a fall. Died at 74 from cardiac syncope. One year before death some doctors diagnosed cancer of bladder, this unconfirmed.

Mother: Apparently healthy. Five children, one dead at

Approximations

birth. At age 45 (menopause?) suffered attacks like
those of Frida's father for the rest of her life. Died at 59
during operation on [gall]bladder. Had breast cancer 6
months before death.

Maternal grandmother: Cancer of eye. Died in old age of
intestinal occlusion.

Paternal grandfather: Died of tuberculosis.

Maternal uncle: Galloping tuberculosis. Died at 23.

Another maternal uncle: Died of liver tuberculosis at 43.

Two half sisters (from father): Complete hysterectomies,
one from cancer of uterus, other from cysts.

Oldest sister: Complete hysterectomy because of cysts,
sterility. Cardiac lesion.

Second sister: Ovary removal due to cysts. Insufficient
ovarian action. Three spontaneous abortions during pe-
riods and in midpregnancy.

Third sibling [brother]: Died of pneumonia a few days
after birth.

Youngest sister: Two normal children. [Only one of sis-
ters giving birth normally.] Cystectomy and resection of
part of pancreas at age 29. (Dr. Gustavo Baz.)

Early life

1910–1917: [Again mentions date of birth changed by
Frida herself.] Normal birth. In early childhood: mea-
sles, chicken pox, tonsillitis in frequent attacks, weight
and development normal.

1918: Blow on right leg from tree trunk; from then on,

slight atrophy in right leg with slight shortening and
foot turned outward. Some doctors diagnosed polio,
others "white tumor." Treatment: sun baths and cal-
cium. However, patient lived normal life at this time,
sports, etc. Mentally normal. Never felt pain or discom-
fort.

1925: Menarche. Normal. [It would not have been very
normal to have started menstruation at age eighteen.]
1926: [The accident mentioned here occurred in 1925,
as can be confirmed by letters sent to Alejandro Gómez
Arias.] Accident causes fractures of third and fourth
lumbar vertebrae, three fractures of pelvis [eleven],
fractures of right foot, dislocation of left elbow, pen-
etrating abdominal wound caused by iron handrail en-
tering left hip, exiting through vagina and tearing left
lip. Acute peritonitis. Cystitis with catheterization for
many days. Three months bed rest at Red Cross hospi-
tal. Spinal fracture not recognized by doctors until Dr.
Ortiz Tirado ordered immobilization with plaster cor-
set for nine months. After three or four months of cor-
set patient suddenly felt entire right side "as if asleep"
for hour or more, this phenomenon giving way with
injections and massage; symptoms not repeated. At re-
moval of corset patient resumed "normal" life, but
from then on has had sensation of constant fatigue and
at times pain in backbone and right leg, which now
never leave her.

1929: Marriage. Normal sex life. Pregnancy in first year

of marriage. Abortion by Dr. J. de Jesús Marín [brother of Lupe Marín, from whom Rivera separated shortly before marriage to Frida] because of malformed pelvis. Wasserman and Kahn tests negative. Constant fatigue and weight loss.

1931: In San Francisco, California, examined by Dr. Leo Eloesser. Given several tests, Wasserman and Kahn among them, these resulting slightly positive. Two months treatment by Leo without cure. No analysis of spinal fluid. Repeated Wasserman and Kahn tests negative. In these days pain in right foot worse, atrophy up to thigh in right leg increases considerably, tendons of 2 toes in right foot retracted, making normal walking extremely difficult. Dr. Leo Eloesser diagnoses congenital deformity of backbone, leaving causes [results] of accident in second place. X-rays show considerable scoliosis and apparent fusion of 3rd and 4th lumbar vertebrae with disappearance of intervertebral meniscus. Analysis of cerebrospinal fluid negative. Wasserman and Kahn negative. Koch's investigation negative. Backbone fatigue continues. Small trophic ulcer appears on right foot.

1932: In Detroit, Michigan, attended by Dr. Pratt of Henry Ford Hospital for second pregnancy (four months) with spontaneous abortion despite bed rest and various treatments. Repeated Wasserman and Kahn tests negative; analysis of cerebrospinal fluid negative. Trophic ulcer continues despite treatments.

1934: Third pregnancy. At three months abortion per-
formed by Dr. Zollinger in Mexico. Exploratory laparo-
tomy showed undeveloped ovaries. Appendectomy.
First operation on right foot: excision of five phalanges.
Extremely slow healing.

1935: Second operation on right foot, finding several
sesamoids. Healing equally slow. Lasts nearly six
months.

1936: Third operation on right foot: excision of ses-
amoids. Periarterial sympathectomy performed as well.
Equally slow healing. Trophic ulcer persists. From that
time on: extreme nervousness, anorexia, continued fa-
tigue in backbone with alternating periods of improve-
ment.

1938: Consults specialists in bones, nerves, and skin in
New York. Continues in same state until seeing Dr.
David Glusker, who succeeds in healing trophic ulcer
with electrical and other treatments. Thick calluses
form on sole of foot [supporting areas]. New analyses
negative. Kahn and W[asserman].

1939: Paris, France. Renal colobacteriosis with high
fever. Continued backbone fatigue. Ingests great quan-
tities of alcohol out of desperation (almost one bottle of
cognac daily). At end of this year has acute pain in
backbone. Attended in Mexico by Dr. Farill, who or-
ders absolute bed rest with twenty kilogram weight to
stretch spine. Several specialists visit at different times:
all advise Albee operation: Dr. Albee himself advises

same by letter. Drs. Federico Marín [another of Lupe
Marín's brothers] and Eloesser oppose this. Fungus in-
fection appears on fingers of right hand.

1940: Moves to San Francisco, California. Treated by
Dr. Eloesser: absolute rest, very nutritious food, no al-
coholic beverages, electrotherapy, calcium therapy. Sec-
ond cerebrospinal tap negative. Introduction of
liopoidal [*liopodol*] for x-rays. Slightly better, again lives
more or less normal life.

1941: Again experiences exhaustion, with continuous
weakness in back, violent pain in extremities. Weight
loss, debility, menstrual irregularity. Sees Dr. Carbajosa,
who begins hormonal treatment of great help in reg-
ulating periods and healing skin infection on fingers of
right hand.

1944: These years show significant increase in tiredness,
backbone and right-leg pain. Seen by Dr. Velasco
Zimbrón, who orders absolute bed rest, steel corset
which at first makes for more comfort but without
stopping pain. When corset occasionally removed, feels
lack of support as though unable to support herself.
Complete lack of appetite continues with rapid weight
loss: six kilos in six months. Weakness, nausea; ordered
to bed, evening fever [37.5 to 37.9]. Consults several
physicians. Drs. Carbajosa and Gamboa inclined to
consider phimotic process. Advise new spinal tap for
diagnostic purposes, absolute bed rest, extremely nu-
tritious food. Seen by Dr. Ramírez Moreno, who leans

toward diagnosis of infections, starting blood transfu-
sion treatment (eight of 200 cc.), sun baths, and very
nutritious food. Patient's state continues worsening.
Bismuth applied. Her general condition continues
worse. Dr. Carbajosa insists on phimotic process. Con-
sultation with Dr. Cosío Villegas, who seems to con-
firm Dr. Carbajosa's diagnosis with clinical picture.
Treatment is absolute rest, methylic antigen, calcium,
and extremely nutritious food. Dr. Zimbrón repeats
analysis and x-ray, lumbar tap with lipoidal injection
[third time]. Injection with negative result. Visited by
Dr. Gea González who guesses that phimotic and luetic
processes coexist. Asks to examine back of eye to begin
arsenic treatment and general treatment for phimotic
procedure. New x-rays in Dr. Velasco Zimbrón's labo-
ratory; he arrives at conclusion that she should be given
a laminectomy and spinal graft [Albee operation]. Eye
examination shows papillary hypoplasia. No operation.
1945: For first time in all these years, considered neces-
sary to put lift on right shoe (two centimeters) to equal-
ize shorter leg. Again made to wear plaster corset (Dr.
Zimbrón). Can be stood for only a few days because of
intense pain in backbone and leg. In the three cere-
brospinal taps there were lipoidal injections which were
not eliminated: caused higher than normal cranial ten-
sion, continued pain in back of neck and spinal col-
umn, generally dull but stronger during nervous
excitement. General state: exhaustion.

1946: Dr. Glusker advises patient to go to New York to see Dr. Philip D. Wilson, surgeon specializing in spinal operations. Leaves for New York in May. Carefully examined by Dr. Wilson and neurology specialists, etc., who consider spinal fusion necessary and urgent. Performed by Dr. Wilson in June this year. Four lumbar vertebrae fused with pelvis graft and fifteen-centimeter-long vitalium plate; bed rest for three months. Patient recovers. Advised to wear special steel corset for eight months, lead calm, restful life. Obvious improvement noted for first three months after operation, after which patient cannot follow Dr. Wilson's orders. Then not convalescing in due form, life filled with nervous agitation, little rest. Feels same fatigue as before, aching neck and backbone, debility, weight loss. Macrocytic anemia. Fungus again appears on right hand. Highly nervous state, intense depression.

In spite of the enormous physical suffering contained in this medical history, Frida Kahlo demonstrated with her existence and her work that social defects are far more oppressive than physical ones. She thought that Karl Marx was right, although she also agreed with Freud and Jeremiah, and spent her forty-seventh birthday singing when she had a voice, dancing when she had legs, screaming when she was angry, and ten days before her death—not supposing it would actually come—gave me a symbolic story of her end.

It had been more than a year since Frida stopped paint-

ing, when in the spring of 1954, eager to recover from the torture of the amputation of her right leg shortly before, with the resulting lack of psychic control she again took up her paint brushes and on a piece of wood painted herself placed vigilantly next to a brick oven that looked like a crematory. Her creative style, always radiant and sexualized, had become gray in that painting; it lacked the polish of her more beautiful works and showed a thick pigment application modeled with a sculptor's attack. Her persona appeared with the rigidity of a paper-and-reed skeleton dressed in a rebozo and pepper-and-salt cloth pants. One night the following summer I stayed in her Coyoacán house, staying with her once again as at other times. When she awakened she asked me to bring her one of her unfinished paintings. She looked at it sleepily, bewildered and sad.

"Didn't you see the other one? It's my face in the middle of a sunflower. It was a commission. I don't like the idea; I seem to be smothering inside that flower."

I looked for it and brought it. It was slightly larger than the first one and the paint was also heavily and violently laid on, but in this one everything was in motion, everything was affirmative, everything turned out to be charming and emotional. Irritated by the vital energy radiating from an object she created, and that she no longer possessed in her own movements, she took a straight-edged Michoacán knife with a coarse motto engraved on the blade, and overcoming the lassitude caused by the nightly injections,

with tears in her eyes and a frozen smile on her trembling lips, she began scraping off the paint slowly, too slowly. The sound of the steel against that very dry oil paint grew like a cry of pain on the morning of that Coyoacán space in which she was born. She scraped in a frustrated way, eliminating and destroying herself, as in a ritual of self-sacrifice.

When leaving the crematorium of Mexico City's civil cemetery, after standing guard for two and a half hours beside the oven where Frida's body had changed into a little hill of calcined bones, and while those present, headed by Concha Michel, intoned the "Internationale", revolutionary songs, and ballads, David Alfaro Siqueiros, who had remained at the oven entrance and had seen how the fire surrounded her marvelous Tehuantepec elegance, said to me: "When the iron slab supporting her body started to enter [the oven] and the flames set her hair on fire, her face seemed to be smiling in the center of a sunflower." A chance event or a premonition very characteristic of Frida, who loved the poems of Li-Tai-Po and made her shield and sign the alert eye of wisdom.

When Frida died she had been married to Diego for twenty-five years—twenty-five years of a passion that knew a balance between pity and cruelty, honesty and mystification. Diego's love had enough genius to nourish Frida's eagerness to live and to be. Absorbed in that support, Frida grew productive and embraced Diego tenderly. She was born of

Diego spiritually and allegorically—daughter and mother, origin and result. From Frida's maternal fire emerged another Diego, Froglike Friend, a priest of pleasant jokes who comforted her and kept her from wasting away. Both of them felt existence as an ongoing process, enforcing certain limits and breaking certain norms. Typical of Frida's style, she expressed in the pages of her diary, which she wrote and illustrated in her long hours of solitude, her strong desire for a constantly unsatiated freedom:

"I'd like to be able to be what I want to be—behind the curtain of madness: arranging flowers all day long; painting pain, love, and tenderness. I'd laugh as I pleased at the stupidity of others and everyone would say: poor thing, she's out of her mind. (I'd laugh at myself especially). I'd build my world so that as long as I lived it would agree with all the worlds. The day or hour and minute I'd live would belong to me and to everyone. My madness would not be an escape of 'work' for others to support me with their labor."

"Revolution is the harmony of form and color, and everything exists and moves under a single law: life. Nobody is apart from anybody else. Nobody struggles by him or herself. All is all and also one. Pain and anguish and pleasure and death are only a process for existing. Revolutionary struggle in this process is an open door to intelligence."

"Childish love. An exact science. The will to tolerate living, a healthful joy, an infinite gratitude. Eyes in the hands

and a sense of touch in the eyes. Cleanliness and a productive gentleness. An enormous vertebral column which is a basis for the whole human structure. We'll see, we'll learn. There are always new things forever tied to the living old ones. Winged, my Diego, my thousand-year-old love."

Several factors contributed to a kind of precocious maturity in the young Coyoacán girl. Her mother, Matilde Calderón y González, a very devout Christian, was unable to breastfeed her because she soon became pregnant again. Her fourth and last daughter, Cristina, born 7 June 1908, was only eleven months younger than Frida. In the painting *Mi nodriza y yo (My Wetnurse and I)*, Frida is shown with an adult face and a baby's body in the arms of a nana-goddess with a flower-sprouting breast in anatomical section, suckling the little one, while the other breast drips milk. Both figures seem to emerge from the painting's surface and are offered to the viewer in a ritual gesture. The mystical or magical climate is accented by the Teotihuacán mask covering the face of the wetnurse, a symbolic being of the aboriginal essences in Frida's blood from her grandfather Antonio Calderón, native of Michoacán. The stone mask, connected to the cult of the dead, appears in this painting as a gift of life, and the hollow pupils, half-open lips, and solemn rigidity seem to guarantee the eternity of the life cycle. This preoccupation with the endless development of life will again be a part of her fantasy in 1949, when she paints *El abrazo de amor entre el Universo, la Tierra, yo y Diego (Love*

Embrace between the Universe, the Earth, Diego and Me), an image of an ingenuous and essential cosmogony. Here the baby with the adult face and the third eye of knowledge in its forehead is Diego Rivera. Frida painted her self-portrait as if trying to offer the little one a maternal embrace, but it is the cosmic wetnurse, big as a mountain, from whose worn breasts grow trees, who truly holds him. The sacerdotal face of the Earth-nurse is not masked; it is the Universe that holds the mask of eternity, with the dark sun and the pale moon that cross their lights above the enormous symbolic arms of day and night. Frida does not express this multiple embrace as something happy, but as a painful determination. This can be deciphered by a stormy sky, scenes filled with sad omens, symbolic scenes appearing in paintings such as *Las dos Fridas* (*The Two Fridas;* 1939); the self-portrait with the "mirror image" of 1937; *Raíces* (*Roots*) of 1943; the self-portrait in men's clothing and a boyish haircut of 1940, *Cortándome el pelo con unas tijeras* (*Cutting My Hair with a Pair of Scissors*), conveying, with nonsense and all, these lines: "Look, if I loved you it was for your hair; now that you're close-cropped, I don't love you any more." Scenes of inconsolable sadness, desolation and barrenness also appear in *Arbol de la esperanza mántente firme* (*Tree of Hope, Stand Fast*) of 1946, *A mi no me queda ya ni la menor esperanza ... todo se mueve al compás de lo que encierra la panza* (*For Myself There is Not the Slightest Hope Left ... Everything Moves to the Rhythm of What the Belly Holds*) of 1945, and *La columna rota* (*The Broken Column*) of 1944.

She reacted to adversity with pride. Flirtatious and extremely sentimental, if circumstances prevented her from exploiting her feminine charms, she would challenge her fate by dressing like a man to reaffirm her strength and hide her physical defects and orthopedic appliances. It is difficult to recognize her dressed as a man, with a Chaplinesque cane and short-cropped, slicked-down hair in photos of her with her sisters, friends, and relatives, these taken between 1926 and 1927.

The process of taking on her new bodily condition must have coincided with an evident radicalization of her ideas about Mexican society, for in 1928 Diego Rivera is representing her in the role of protagonist in the panel entitled *El arsenal* (*The Arsenal*) in the Secretariat of Public Education, a panel placed at the end and as the finishing touch to *El corrido de la Revolución* (*Ballad of the Revolution*). This is a mural on the top floor, where he said in images that it was not enough to criticize the defects of the dependent, corrupt, and exploitative bourgeoisie, but that one must take up and distribute the arms of the popular revolution.

The masculine attire of the twenty-year-old Frida was like a banner of her self-determination; she may have been thinking of George Sand or Rudolph Valentino. She had a whimsical desire to combine the breakaway attitude of the "liberated" baroness with the ladies' man on whom cinematographic makeup would confer androgynous qualities.

When Rivera returned to Mexico after fifteen years in

Europe, he had again become devoted to the unmistakably Mexican woman, and he exalted her Tehuantepec attire to the point of euphoria. Playfully affectionate and not without some roguery, he convinced Frida to change her man's clothing for mestizo or native dress. From then on it was difficult to imagine Frida out of her Mexican garb. The Tehuantepec dress made her shine with the greatest elegance. But in the language of clothing, and true to the couple relationship, she considered her apparent nativism as a concession to Rivera—a kind of lover's knot—to such an extent that it was in a period of distancing, formalized by the divorce, when she painted herself dressed as a man with a boy's haircut and surrounded by all the hair furiously scattered by a sadomasochistic pair of scissors.

The singular relationship between Diego and Frida is better understood when we read the expressions of intense tenderness appearing occasionally in the diary she kept without discipline but with passionate sincerity:

"Diego, there's nothing to compare with your hands and nothing like the green-gold of your eyes. My body fills up with you for days on end. You're the mirror of night, the violet light of a lightning flash, the dampness of earth. My refuge is in the hollow of your armpits. My fingertips touch your blood. All my joy is to feel your life gushing out of your fountainhead-flower which mine protects to fill all the paths of my nerves that belong to you."

"Diego. It's really so great that I wouldn't want to talk or sleep or hear or love. To feel locked in, without fear of blood, without time or magic, within your own fear and great anguish, and in your very heartbeat. It's all madness; if I should ask you for it, I know what would happen because of your silence—only embarrassment. I beg you for some violence in the wrong, and all you give me is thanks, your light and warmth. I'd like to paint you, but there aren't enough colors, though I have so many, and in my confusion the concrete form of my great love doesn't exist."

"Never have I seen a greater tenderness than Diego's, and what he gives of it when his hands and his beautiful eyes touch the Mexican sculptures. Nobody is any more than a performer or a part of a total operation. Life goes by and gives us roads that are not traveled in vain. But no one can stop freely to play on the way, because he or she postpones or changes the atomic and general journey. That causes unhappiness, that causes despair and sadness. We should all like the whole thing and not the numerical part of it. Changes and struggle disconcert and terrify us because they're continuous and true; we seek calm and peace because we anticipate the death we die at every second. Opposites unite and we discover nothing new or irregular. We find protection in the irrational, the magical, and the abnormal for fear of the extraordinary beauty of the certain, the material and dialectical, the healthy and strong. We enjoy being sick to protect ourselves. Someone—

something—always protects us from the truth; our own ig-
norance and fear. Fear of knowing that we are nothing
more than vectors—construction, and destruction to be
alive and feel the anguish of waiting for the next minute
and participating in the complex current of not knowing
that we ourselves are headed toward the millions of stone-
beings, bird-beings, star-beings, microbe-beings, source-
beings. We ourselves: a variation of the one unable to es-
cape to the two, to the three, etc.—always returning to the
one. But not to the whole, at times called God, at times
liberty, at times love. No, we are hatred, love, mother,
child, plant, earth, light, lightning, etc. Always a world, a
giver of worlds, universes, and universe cells. That's all."

"Nobody will ever know how much I love Diego. I
don't want anything to hurt him, nothing to bother him
and rob him of the energy he needs for living, for living as
he likes. For painting, seeing, loving, eating, sleeping, being
by himself, being with someone; but I'd never want him to
be sad. If I had good health, I'd like to give him all of it; if
I had youth, he could take it all. I'm not only a mother-
fool, I'm the embryo, the germ, the first cell—
potentially—that engendered him. I am Diego from the
oldest and most primitive cells which will in time become
him."

"At every moment he's my child, my child born every
little while, every day, from my own self."

"Luckily, words were evolving. Who gave them absolute

truth? Nothing is absolute. Everything changes, everything moves, everything revolutionizes, everything flies away and vanishes . . .

> *Diego the beginning*
> *Diego the builder*
> *Diego my child*
> *Diego the painter*
> *Diego my lover*
> *Diego my husband*
> *Diego my friend*
> *Diego my mother*
> *Diego my father*
> *Diego my child*
> *Diego me*
> *Diego the universe.*

Diversity in unity. Why do I call him my Diego? He was never mine and never will be. He belongs to himself."

"Silent life, giver of worlds, what matters most is no-hope. Morning dawns, red friends, great blue spaces, leaves in the hands, noisy birds, fingers in the hair, nests of doves, a rare understanding of the sister struggle, simplicity of the song of injustice, madness of the wind in my heart. Gentle Xocolatl of ancient Mexico, a storm in the blood that enters by mouth. Compulsion, omen, laughter and perfect teeth, pearl needles for some seventh of July gift. I ask for it and get it; I sing, singing, and I'll sing our love-magic from today onward."

Three
Frida by Frida

It has repeatedly been said, and rightly so, that Frida's paintings are a courageous and valuable testimony of her own life. What existence is this that has produced a reality of art so stirring, wounding, beset with difficulties, austere, tragic, loving, heartbreaking, and happy in all its varied expressions?

I met Frida one May afternoon in 1953, and for some brief and intense days I lived in her world, where sincerity was so evident. It was a time of extreme pain for that strangely beautiful woman who had suffered inordinately. The pain exploded like sequences out of a stubborn and capricious bag of tricks. Serenely spirited in the midst of her

distress, she told me fragments of her life, a story disconcerting and difficult to understand in the sense of my fully identifying with her.

"I was born in Coyoacán on the corner of Londres and Allende streets. My parents bought some land that was part of the Carmen hacienda and built our house on it. My mother, Matilde Calderón y Gonzalez, was the oldest of the twelve children of my Spanish immigrant grandmother Isabel, daughter of a Spanish general, and my grandfather Antonio, a Native American from Morelia in Michoacán. My grandmother and her sister Cristina were educated in a las Vizcaínas convent, where they were taken when the general died. So when Isabel left, she married Antonio Calderón, a professional photographer who made daguerreotypes.

"My mother was a friend of the gossips, the children, and the old women who used to come to the house to pray their rosaries. During the Tragic Decade [the Mexican Revolution] my mother would open the balcony windows on the Allende Street side and welcome the zapatistas [followers of Emiliano Zapata]. She'd attend to their wounds and give the hungry thick corn tortillas, the only food she could find in Coyoacán in those days. I was seven at the time of the Tragic Decade, and I saw with my own eyes the peasant struggle of Zapata against the carrancistas [followers of Venustiano Carranza]. The clear and precise emotion I remember about the Mexican Revolution made

*me join the Young Communists at the age of thirteen, but
in 1914 the bullets began to hiss; I can still hear their ex-
traordinary sound. There was propaganda for Zapata in
the Friday markets of Coyoacán in the form of ballads il-
lustrated by José Guadalupe Posada, and they cost one cen-
tavo. Cristi and I used to sing them, shut up in a large
closet smelling of walnut wood, while my mother and fa-
ther kept watch for us. I remember a wounded carrancista
running toward his post beside the Coyoacán river, and a
zapatista crouching with a bullet wound in his leg as he
was putting on his huaraches.*

*"I remember that my mother was never in need of any-
thing; she always had five silver pesos stashed away in her
bureau drawer. Born in Mexico City, she was a short
woman with beautiful eyes, a very fine mouth, and dark
skin—she was like a Oaxaca bellflower. When she went to
market, she would fasten her belt gracefully and coquet-
tishly carry her basket. Mamá was very congenial, active,
and intelligent, but didn't know how to read or write, only
to count money. She died young, at fifty-nine.*

*"My father, Guillermo Kahlo, was a very interesting
man, quite elegant in his movements, his walk; calm, in-
dustrious, courageous, and with few friends. I remember
two of them; one was a tall old man who always left his
hat on top of the wardrobe. My father and the old man
would spend hours together, playing chess and drinking
coffee. The son of Hungarians, my father was born in 1872
in Baden, Germany, and he studied in Nurenberg. His*

*mother died when he was eighteen, and he didn't like his
stepmother, so my grandfather, a jeweler, gave him enough
money to go to America, but when he arrived in Mexico in
1891 he suffered frequent attacks of epilepsy. At the age of
twenty-three he married and two daughters were born of
this marriage: María Luisa and Margarita. His first wife
died on giving birth to Margarita. The night his wife died
my father called my grandmother Isabel, who arrived with
my mother. She and my father worked in the same store
and trusted one another, so he fell in love with her and
they later married. María Luisa was seven and Margarita
three when they were put into the Tacuba convent. Mar-
garita was going to be a nun and the religious people mar-
ried off María Luisa to a Jalisco man, by correspondence.
María Luisa has always been a very hardworking girl; she
has never asked for a cent, and she lives in a room that
costs her forty-five pesos a month rent. She doesn't go back
on her word and doesn't lie, which is very much like my
father."*

Those who knew Guillermo Kahlo agree with Frida in
describing him as a kindly man with fine manners, very
industrious. In August of 1976 the North American In-
stitute of Mexico put on an exhibition called "Homage to
Guillermo Kahlo, First Official Photographer of the Cul-
tural Patrimony of Mexico." For the catalogue, Francisco
Monterde gave a description just like Frida's:

I met Don Guillermo shortly after having gone into the
Constitutionalist Army in Mexico. In those days I had
started my career in journalism under the affable lead-
ership of Mariano Urdanivia. Between 1915 and 1917 I
was editorial secretary of the magazine *México* and
chief editor of the magazine *Tricolor*. In both of them I
had to fill most of their pages with reproductions of
photos of landscapes and buildings and portraits of our
most important people, so I went frequently to Don
Guillermo, and his excellent archives and unchanging
kindness always saved me. I remember him as being
sober and courteous, with graying hair. He had that
rare virtue of knowing how to listen, understanding
what was being asked of him, and being always ready
to help when providing his artistic photographs.

Frida recalled:

*"My grandfather Calderón was a photographer; that's why
my mother convinced my father to become one. The father-
in-law loaned him a camera, and the first thing they did
was take a tour around the republic. They obtained a col-
lection of photos of indigenous and colonial architecture,
and after their return, they opened their first studio on Six-
teenth of September Avenue, which is saying a lot. From
that time on there were hard days at home."*

For that same exhibition of homage to Guillermo Kahlo, the National Institute of Anthropology and History contributed the following facts:

It was 1904 when José Ives Limantour, secretary of the treasury in the government of General Porfirio Díaz, received in his office a slender, thirty-two-year-old man with large blue eyes and a lively look. His name was Guillermo Kahlo, his profession that of photographer. Six years before the event, Kahlo was already thinking about the programs to celebrate the first centenary of Mexican independence, and among them was a line of publications being planned in a most luxurious format. Secretary Limantour had selected Mr. Kahlo to provide the necessary illustrations and commissioned him to travel around the country to photograph historically important colonial buildings and monuments, as well as those built during the time of Porfirio Díaz. So Mr. Kahlo became the first official photographer of Mexico's cultural patrimony.

Impressed at the outset by the abundant artistic and architectural richness of the Mexican churches, monuments, and other buildings, Kahlo gave more time and effort to them than to the merely commercial photographs. This specialty, acquired by not one photographer of the Mexico of those days, led him to the office of Secretary Limantour, and from 1904 to 1908 he persisted in his mission of traveling throughout the coun-

try and clicking his shutter at the exteriors and
interiors of churches and monuments and then printing
his daguerreotypes. He himself prepared the glass
plates with their sensitive coatings, which rather fre-
quently caused certain photographic defects, yet he had
come to master his equipment and technique so well—
to which he added a developed artistic sense—that he
was able to capture the slightest details, the play of
light and shade, and especially the very atmosphere of
the places and objects he photographed.

"He printed more than nine hundred plates, which
he handed over to Limantour, who used some of them
in illustrating several of the books published to com-
memorate the centenary of independence; they re-
mained in the ministry building under Porfirio Díaz,
and later in the Secretariat of the Treasury and Public
Credit, consigned to the National Welfare Administra-
tion. In 1946 this became the office of the secretary of
state, whose titular head, some time later, thought that
Kahlo's daguerreotypes should be in the custody of the
Institute of Anthropology and History, where they are
now to be found.

About her parents Frida observed:

*"Physically I look like both of them; I have my father's
eyes and my mother's body. [There were many tempera-
mental likenesses between Frida and her father; he was the*

*one who gave her one of the attributes that would help her
cope with her tragic condition: the ability to rise above her
physical pain by clinging to life—not with moaning and
groaning but with action and production.]*

"My mother couldn't breast-feed me, because when I
was eleven months old my sister Cristina was born. A nana
fed me, and they washed her breasts every time I nursed. In
one of my paintings—with the face of a grown woman
and the body of a little girl—I'm in the arms of my nana,
while the milk runs out of her breasts as if from heaven.

"Between three and four years old Cristi and I were sent
to a school for very little ones. The teacher was an old-time
woman with false hair and a very strange way of dressing.
My first memory goes back to this teacher in particular: she
was stopped in front of a pitch-dark hallway, holding a
candle in one hand and an orange in the other, explaining
how the universe, the sun, the earth, and the moon are ar-
ranged, but I wet my pants from the impression this gave
me. They took off my wet pants and put on some that be-
longed to a girl who lived across the street. And because of
this incident I developed such a hatred for that little girl
that I took her near my house one day and started to choke
her. Her tongue was hanging out of her mouth when a
baker came along and yanked her away from me.

"After that I took part in the religious thing, and at the
age of six I had my First Communion. [With Frida's con-
stant change of dates, we can assume that this ceremony
occurred when she was nine. At any rate, the contrast be-*

tween the liberal father of Jewish ancestry and the fanatically Christian mother was another of the things that nourished her precocity.] So Cristi and I were made to go to catechism for a year, but we used to escape and to eat hawthorn fruit, quinces, and cherries in a nearby orchard.

"One day my half sister María Luisa was sitting on the potty when I pushed her and she fell backward with the potty and everything. She was furious and said to me: 'You aren't the daughter of your mamá and my papá; they picked you up out of a garbage can.' That statement hit me so hard that I became completely introverted. It was about then that I began my adventures with an imaginary friend. I went to find her in a store with the word PINZON painted on its windows in big letters. On a window of what was then my room, and which looked out on Allende Street, I'd blow my breath on one of the lower panes of glass and draw a door on it with my finger. I went out through that door in my imagination, and with great joy and urgency traveled across a field I saw until I reached the store and dairy called PINZON. I entered through the O of PINZON and suddenly found myself in the middle of the earth, where my imaginary friend was always waiting for me. I don't remember what she looked like or what color she was, but I do know she was full of joy and laughed a lot, though without making a sound. She was smart and danced as if she weighed nothing at all. I followed all of her movements, and while she was dancing I told her all my secret problems. Which ones? I don't re-

*member, but she could tell everything about me by my
voice. When I returned to my window, I came back by the
same door drawn on the glass. How long had I been with
her? I don't know—maybe a second or thousands of years.
I was happy. I rubbed out the door with my hand and she
disappeared. With my secret and my happiness I ran to a
corner of the patio of my house and always in the same
place—under a cedar tree—I'd shout and laugh, as-
tonished at being alone with my happiness and with such a
vivid memory of that little girl.*

*"At the age of six I had polio, and since then I remem-
ber everything clearly. For nine months I had to stay in
bed. It all started with a terrible pain in my right leg, from
the thigh downward. They'd soak my little leg in a small
tub of walnut water and hot cloths, and the poor little leg
stayed very thin. At seven I used small boots. At first I as-
sumed that the children's taunts wouldn't affect me, but
later they really did, and each time worse.*

*"At seven I helped my fifteen-year-old sister Matilde es-
cape to Veracruz with her boyfriend. I opened the balcony
door for her and then shut it as if nothing had happened.
Because Matita was my mother's favorite, her flight made
Mamá hysterical. What made Matita want to leave? My
mother was hysterical because she didn't know.*

*"As for me, it was horrible to see how Mamá took the
mice out of the cellar and drowned them in a barrel, and
didn't leave them till they were thoroughly dead. That gave
me a terrible feeling. Sobbing, I said to myself: 'Oh,*

*Mother, you're so cruel!' Maybe she was cruel because she
wasn't in love with my father. When I was eleven, she
showed me a book bound in Russian leather, where she
kept the letters from her first sweetheart. On the last page
of the book was a note saying that the writer of the letters,
a young German, had committed suicide in her presence.
She always remembered that man, and she gave the
leather-bound book to Cristi.*

"*My mother was a great friend to me, but the religious
thing never brought us close to each other; she would reach
the point of hysteria for her religion. We had to pray before
meals, and while the rest were concentrating, Cristi and I
would look at each other trying not to laugh. For twelve
years my mother was strongly against me religiously, and at
thirteen I started being active in leftist student organiza-
tions. [According to Frida's altered calendar, could it have
been at thirteen or sixteen?]*

"*When Mati went away, my father didn't say a word.
His frame of mind made it difficult for me to believe he
actually did have epilepsy, in spite of the many times he
would suddenly fall down while walking with his camera
slung over his shoulder and holding my hand. I learned
how to help him during his attacks in the middle of the
street. On the one hand I was careful to have him breathe
ether or alcohol right away, and on the other I kept watch
so that nobody would steal his photographic equipment.
[He might not have had the money to replace it. In those
days it was more than half a century since photography had*

*come to Mexico, and after the Revolution, professional
competition was difficult because there were many more
professional photography studios. Kahlo tried hard to ac-
commodate himself to modern times; he went into commer-
cial photography, still printed daguerreotypes, made
portraits of important people, took pictures of Mexico City
and other places, and even went so far as to collaborate on
the book* Las Iglesias de México *(*Mexican Churches*)
with Dr. Atl, but he did not prosper financially and did
have many difficulties.]*

"We spent four years without seeing Matita, and while
we were in a street car one day my father said to me:
'We'll never find her.' I consoled him, and my hopes were
really sincere. I was twelve years old when a friend from
the Preparatory School told me: 'On the street where the
doctors live there's a woman who looks exactly like you
and her name is Matilde Kahlo.' At the back of the patio,
in the fourth room of a wide hallway, I found her. The
room was filled with light and birds and Matilde was
bathing herself with a hose. She was living there with Paco
Hernández, whom she later married, and they had enough
money and no children. The first thing I did was tell my
father I'd found her. I visited her several times and tried to
convince my mother to see her, but she refused.

"The things I played with were boys' things: skates and
bicycles. Since my parents weren't rich, I had to work in a
lumberyard, and my work consisted of controlling how
many beams went out each day, how many came in, and

their color and quality. I worked in the afternoons and
went to school in the mornings. They paid me sixty-five
pesos a month, but I didn't take one centavo for myself.
Before the bus crushed me I wanted to be a physician."

Frida never talked about an early literary vocation, but in
El Universal Ilustrado, of 30 November 1922, there was
published on page 61 a prose poem of hers titled "Re-
cuerdo" ("Memory"), whose content is understandable
coming from the fifteen-year-old girl she really was, and not
from the twelve-year-old girl she pretended to be. This is
what she wrote:

All I had done was smile, but there was innocence in me
 and in the depth of my silence.

He, he was following me. Like my shadow, irreproachable
 and unsteady.

At night he sobbed a song . . .
Through the town alleys the Indians sinuously moved
 away; wrapped in serapes they were on their way to a
 dance, after drinking mescal. A harp and a small guitar
 furnished the music and some smiling dark-skinned girls
 supplied the gaiety.
Beyond, behind the Zócalo, shone the river, flowing like
 the minutes of my life.
He, he was following me.
I ended up crying, crouched in the atrium of the parish

*church and wrapped in my beaded rebozo, drenched in
tears.*

This is how Frida explained to me her accident of 17 September 1925:

*The buses in those days were absolutely flimsy; they had
started to run and were very successful, but the streetcars
were empty. I boarded the bus with Alejandro Gómez
Arias and was sitting next to him on the end, beside a
handrail. Moments later the bus crashed into a streetcar of
the Xochimilco line, and the streetcar crushed the bus
against the street corner. It was a strange crash, not violent
but dull and slow, and it injured everyone, me much more
seriously. I remember that it occurred exactly on the seventeenth of September, the day after the festivities of the sixteenth. I was eighteen then but I looked much younger,
even younger than Cristi who was eleven months younger
than I.*

*"The collision happened just after we got on the bus. We
had first taken another bus, but I had lost a pretty parasol
and we got off to look for it, and that's how we came to
climb onto that bus that destroyed me. The accident happened on a corner across from the San Juan market, exactly
in front of it. The streetcar was going slowly, but our bus
driver was a very nervous young man, and when the streetcar turned around, it dragged the bus against the wall.*

*"I was an intelligent young girl but not very practical,
in spite of the freedom I'd won. Maybe for that reason I*

didn't size up the situation, nor did I have any inkling of the kind of injuries I had. The first thing I thought of was a pretty-colored cup-and-ball toy I'd bought that day and had with me. I tried to look for it, convinced that all of this wouldn't have any major consequences.

"Nobody could possibly notice the crash or cry, I thought; there were no tears in me. The collision had thrown us forward and the handrail went through me like a sword through a bull. A man saw that I was having a tremendous hemorrhage and carried me to a nearby poolhall table until the Red Cross picked me up.

"I lost my virginity, a kidney was bruised, I couldn't urinate, but the thing I complained about most was my backbone. Nobody paid any attention to me and besides, they didn't take any X-rays. They sat me down as well as possible and I told the Red Cross people to call my family. Matilde saw the account in the newspapers and was the first to come, and she didn't leave me for three months; day and night she was by my side. My mother was speechless for a month because of the effect and did not come to see me. When my sister Adriana heard about it, she fainted. It caused my father so much sadness that he took sick and could only come to see me three weeks later.

"I was at the Red Cross hospital for three months—the place was very poor. We were kept in a kind of tremendous slaves' quarters, and the meals were so vile they could hardly be eaten. One lone nurse took care of twenty-five patients. Matilde was the one who lifted my spirits by tell-

ing me jokes; she was fat and rather ugly, but she had a
great sense of humor and made all the people in the room
burst out laughing. She would knit and help the nurse take
care of the sick. My student friends in the Preparatory
School came to ask for me and bring me flowers and try to
distract me. They were the ones in the 'Cachuchas,' a
group of boys whose only female member was myself. One
of them gave me a doll I still have. I kept that doll and
many other things because I love things, life, and people a
great deal, and I don't want people to die. I'm not afraid of
death, but I want to live. It's pain I really can't stand.

"As soon as I saw my mother I said to her: 'I'm still
alive and besides, I have something to live for, and that
something is painting.' Because I had to be lying down
with a plaster corset that went from the clavicle to the
pelvis, my mother ingeniously made a very funny contriv-
ance that supported the easel I used to hold the sheets of
paper. She was the one who thought of making a top to my
bed in the Renaissance style, a canopy with a mirror I
could look in to use my image as a model."

Since Coyoacán was quite far from Mexico City, where
Frida's best friends lived, she got used to writing letters.
Sometimes she would write two or three a day. Alejandro
Gómez Arias, whose injuries in the accident were less
serious than hers, kept those addressed to him very care-
fully. Isabel Campos, a companion since primary school
days, also kept messages, letters, and photos. The affection-

ate letters were a moving testimony of those times when Frida began to accept, with a sadly playful spirit, her irreversible tragedy. The first ones were written in the Red Cross hospital.

> TUESDAY, OCTOBER 13, 1925: *You, more than anyone, must know how sad it's been in this filthy hospital; you can imagine it and besides, the boys must have told you. They all say I'm not so hopeless, but they don't know what three months of staying in bed—which is where I have to be—means to me, having been a first-class gadabout all my life. But what can a person do; they don't even let me die, right?* [She draws a skull here.]
> DECEMBER 5, 1925: *The only thing good about me is that I'm beginning to get used to suffering.*

In 1926 when she knew she would never be able to carry a baby to term, she wrote a card with elaborate lettering:

<div align="center">

LEONARDO

IN THE YEAR OF GRACE 1925, IN THE MONTH OF SEPTEMBER, IN THE RED CROSS HOSPITAL, A SON WAS BORN, BAPTIZED IN THE VILLAGE OF COYOACAN THE FOLLOWING YEAR

HIS MOTHER

FRIDA KAHLO

HIS GODPARENTS

ISABEL CAMPOS
& ALEJANDRO GOMEZ ARIAS

</div>

20 OCTOBER 1925, A TUESDAY: *According to Dr. Díaz Infante, who took care of me at the Red Cross hospital, nothing is very dangerous now, and I'm going to be more or less well. The right side of my pelvis is dislocated and fractured, a foot is dislocated, I have a small fracture and dislocation of the left elbow, and the wounds I explained to you in the other letter—the longest one— went through me from the hip to between my legs, so there were two, one already closed and the other about two centimeters long by one and a half deep, but I think it will close very soon. The right foot is full of very deep cuts and another of the things I have is [. . .] Dr. Díaz Infante (who is a simpering fool) doesn't want to keep on taking care of me because he says Coyoacán is too far away and he couldn't leave an injured person and come when I needed him, so they changed him for Dr. Pedro Calderón in Coyoacán; you remember him? Well, since every doctor says something different about the same symptoms, Pedro of course said he found me quite well, all told, except for the arm, and he has grave doubts that I'll be able to stretch it out since the articulation is good but the tendon is tightened and doesn't let me stretch the arm forward, and if I could eventually extend it, the process would be quite slow with a lot of massage and hot water baths. You have no idea how it hurts; every time it knocks against something I shed a liter of tears, in spite of the saying that "you don't have to believe in a dog's limp or a woman's tears." My paw hurts me very much; you have to realize that it was*

*crushed and besides, they punch me horribly all along the
leg and you can imagine how annoying that is, but they
tell me with rest the bone will soon heal and that little by
little, I'll be able to walk. In time.*

8 JANUARY 1927: *Bring me a comb from Oaxaca if
you can, the kind made of wood, all right? You'll say I
never get tired of asking for things.*

10 JANUARY 1927: *I'm the same as ever—sick—
and you can see how boring it is; I don't know what to do
any longer, because I've been like this for over a year and
I've reached the limit, having so many attacks like an old
woman. How will I be when I'm thirty? You'll have to
carry me around wrapped in cotton all day long; there's no
way you can carry me in a bag, as I once told you, because
I wouldn't fit, even stuffed in [. . .] You have to tell me
something new, because I was really born to be a flower-
pot, never leaving the porch. I'm* buten, buten *bored!!!!!!*
[Frida enjoyed inventing words; buten *meant "overmuch,
incredibly excessively."] You'll ask me why I don't do some-
thing useful, etc., but I don't even want to do that, I'm
only . . . saxophone music, you know, and that's why I'm
not explaining it to you. Every night I dream about this
place where I have a room, and no matter how I toss and
turn over and over again, I can't erase the image from my
head (and every day it looks more like a bazaar). Well,
what are we going to do but wait and wait . . . [. . .] I so
often dreamed of being a navigator and a traveler. Patiño
would answer me that it's one of life's ironies. Ha ha ha*

*ha! (don't laugh). But I've only been living in my village
for seventeen years [It was twenty.] Later I'll surely be
able to say . . . Just passing by—no time to talk to you.
[Here she draws some musical notes.] Well, after all, know-
ing China, India, and other countries is in second place . . .
in first place is when are you coming? I don't think I have
to send you a telegram telling you I'm in agony, do I?
[. . .] Listen, let's see if among your acquaintances over
there they know a good recipe for untangling hair; don't
forget. [Alejandro Gómez Arias was studying in Germany,
where his family had sent him to cool off his close relation-
ship with Frida.]*

30 MARCH 1927: *[From a letter to Alicia Gómez
Arias, Alejandro's sister.] Please don't think badly of me if I
don't invite you home, but in the first place I don't know
how Alejandro would take it, and in the second place you
can't imagine how horrible this house looks, and it would
make me very embarrassed if you came, but I'd like you to
know that my wishes are completely the opposite [. . .]
I've been leaning back in an armchair for eighteen days
and I still have nineteen days more of having to be in the
same position (Alejandro must have told you that my spine
has been bad because of the accident), and probably after
those nineteen days they'll put me on a board or in a plas-
ter corset, so you can imagine how desperate I'll be. But
I'll go through all that suffering if only it will give me
some relief, because I'm completely bored not to be able to
do anything, to be always an invalid. [. . .] I'm trying to*

find the address of my papá's sister who lives in Pforzheim, Baden, because it would be very easy to communicate with Alejandro through her. I'm a little doubtful of finding it, because it's been a long time since we've heard from my papá's family, due to the war.

6 APRIL 1927: *I've been in this armchair for seventeen days and I don't feel any relief at all; the pains are as strong or stronger than ever, and I'm completely convinced that this doctor was pulling my leg, because nothing he's told me to do is of any help. Now that a month has gone by, I'm going to talk to him straight out, because I have no intention of spending my life the way he wants me to. [. . .] If I keep on like this, it would be better for me to be eliminated from the planet; the only thing that gives me hope is that later in July [. . .] But the only visitor I honestly wait for will come from Veracruz some day in July— and as usual . . . he'll drink a lot—he'll give up . . . Obregón, The Preparatory School! (This isn't a stridentist poem).*

10 APRIL 1927: *Besides all those other things that distress me, my mamá is sick too, my papá has no money, and I'm suffering—it's no lie—just because Cristina is paying no attention to me and not straightening up my room. Whenever I want something, I have to ask for it by saying please; she mails my letters when she feels like it, and picks up everything she wants to. [. . .] The only thing that entertains me a little is reading. I've already read* Juan Gabriel Borkman *five times and* La bien plan-

tada *about six or seven, and a newspaper article that comes out every day called "The Russian Revolution" by Alexander Kerensky—today's will be the last—and about what's happening in Shanghai. I'm learning German, but I still can't get through that devilish third declension. [She assumes that Alejandro understands a reference to a letter from someone, and adds]: He also asks if I want to paint a "very modern" portrait of him, but I can't and there's nothing to do about it. He'd surely like one that had the Ocotlán chapel as a background or something purely Tlaxcaltecan or Tintónish. This time his life won't fit in with his thinking.*

GOOD FRIDAY, 22 APRIL 1927: *The old doctor says the corset is effective when it's properly placed, but there's still no evidence of this, and if the devil doesn't take me, they're going to put me in the French Hospital on Monday [. . .] The only advantage of this filthy thing is that I can walk, but since walking hurts my leg so much, the advantage is counterproductive. Besides, I'm not going out into the street looking like this, because if I do, they'll surely haul me off to the insane asylum. On the remote chance that the corset isn't effective, they'll have to operate on me, and the operation—according to the doctor— would consist of taking a piece of bone from a leg and putting it in my backbone, but before this happens I would wipe myself totally off the planet [. . .] I'm bored with the W of Woe is me!*

25 APRIL 1927: *Yesterday I was in a lot of pain and*

*very sad; you can't imagine how desperate a person gets
with this sickness; I feel a frightful discomfort I can't ex-
plain, and there's also a pain that nothing can stop. Today
they were going to put me into that plaster corset, but it
may have to be Tuesday or Wednesday because my papá
doesn't have the money—and it costs sixty pesos. It isn't so
much the money, because that could easily be gotten, but
because nobody believes I'm really in pain; I can't even say
I am because my mamá, who's the only one to lose heart,
gets sick and blames it on me for being so stupid. That's
why I'm the only one to suffer, lose hope, and everything. I
can't write much because I can hardly bend, I can't walk
because my leg hurts horribly, I'm tired of reading—I
don't have anything good to read—and all I can do is cry,
and sometimes I can't even do that. Nothing amuses me,
and I don't have a single distraction except for my pains,
and all the people who come to see me at times annoy me a
lot [. . .] You have no idea how the four walls of my room
discourage me! Everything does. I can't explain my hope-
lessness at all.*

SUNDAY, 31 APRIL 1927, LABOR DAY: *On Fri-
day they fitted me with the plaster apparatus, and since
then it's been a veritable martyrdom that can't be com-
pared with anything else. I feel choked, there's a frightful
pain in the lungs and all down my back, I can't even touch
my leg and can hardly walk or sleep. Just think, they had
me hanging head down for two and a half hours, then rest-
ing on tiptoes for over an hour, to dry the plaster by hot*

*air, but when I came home, it was still completely wet. I
was put in the Hospital for French Women, because in the
French Hospital I would have had to stay for at least a
week—they don't allow anything else—and I went into
the other hospital at a quarter past nine and left at about
one. They didn't let Adriana or anyone else come in, and
being entirely alone made me suffer horribly. I'm going to
have to endure this martyrdom for three or four months,
and if this doesn't relieve me I really want to die, because I
can't stand any more. It isn't only the physical suffering,
but I haven't the least diversion, I don't leave this room, I
can't do anything, I can't walk, I'm completely hopeless—
and the main thing is you're not here. Added to all this,
I'm constantly hearing the suffering of other people; my
mamá is still very sick, having had seven attacks this
month, and my papá too, and without any money. It's a
reason for total despair, no? I get thinner every day, and
nothing amuses me any more.*

SATURDAY, 7 MAY 1927: *When I'm a little more
used to this confounded apparatus, I'm going to paint a
portrait of Lira and look into something else. I'm* buten
depressed [. . .] *Salas loaned me* La linterna sorda [The
Dark Lantern] *by Jules Renard, and I bought* Jesús *by
Barbusse. That's all I've read. I'm going to read* El faro
[The Lighthouse].

SUNDAY, 27 MAY 1927: *I don't want you to be
worried about me because, though I'm very discouraged,
my illness isn't dangerous, even though I'm suffering so*

much—you know how I am—but it's better to be sick when you're so far away [...] I'm going to study all I can, and now that I'm a bit relieved, I'm going to paint and do a lot so when you come I'll be a little better: it all depends on how long I'm sick. In eighteen days I'll have been lying down for a month, and who knows how long I'll be in this box, so for the time being all I do is cry.

TUESDAY, 29 MAY 1927: *My father said when I'm better he's going to take me to Veracruz; he's* buten *with the green sea, but there isn't any cash (something else that isn't news) and we have to wait to see if he can keep his promise. I've been getting more and more bored for some time, and if this keeps up I'll end by going stark raving mad, but when you come back all this boredom won't exist [...] Some people are born under a star and others are all smashed up, and even if you don't want to believe it, I'm one of the very badly smashed up.*

LAST OF MAY 1927: *The portrait of Chon Lee is almost finished, so I'll send you a photo of it [...] I'm worse every day, so they're going to have to convince me an operation is necessary, almost certain, because otherwise time will pass and then nearly a hundred pesos will go down the drain, because the money was given to a couple of robbers like most doctors are, and the pains in the bad leg continue just the same, and there are times when the good leg hurts too, so I'm worse every moment and without the slightest hope of getting better, since for that the main thing is money. I have a damaged sciatic nerve and another*

whose name I don't know, but it branches off from the
genital organs, two damaged vertebrae I don't know the
names of either, and a buten *of things I can't understand,*
so I don't know what the operation consists of because no-
body can explain it to me and I can't explain it to you. You
can imagine by all I tell you what great hopes I have of
being—I'm not saying well, but at least better by the time
you come. I realize in this case I must have a lot of faith,
but you can't imagine for a single moment how much I'm
suffering with this thing, because right now I don't believe
I can ever be any better. Some doctor who might be inter-
ested in me could be the one to at least improve my condi-
tion, but all the doctors who've seen me are jackasses who
aren't concerned with me at all, and who only want to rob
people. So I don't know what to do, and to be hopeless is
useless [. . .] Lupe Vélez is filming her first movie with
Douglas Fairbanks, did you know? How are the movies in
Germany? What other things about painting have you
learned? Are you going on to Paris? What is the Rhine
like? German architecture? Everything.
SATURDAY, 4 JUNE 1927: *On Monday they're*
going to change my apparatus for the third time, this time
to keep me stationary, without being able to walk for two
or three months, until my backbone is perfectly mended,
and I have to have an operation later. At any rate I'm
bored and often believe I'd do better to be carried off at
once . . . by the big reaper, no? I'm never going to do any-
thing with this miserable affliction, and if this is at seven-

teen [remember that she would be twenty in a few days] I
don't know what it'll be like later. I'm thinner every day,
and you'll see when you come home how you're going to
take a step back when you see how horrible I am with this
confounded apparatus *[she inserts a drawing here.] It's*
discouraging, no? Later I'm going to be a thousand times
worse; you can figure out that after I've been lying down
for a month, as you left me, and another month with a dif-
ferent apparatus, and now another two months flat on my
back and put into a plaster sheath, after six again with the
small apparatus to let me walk, and with the magnificent
hopes of an operation and my staying under the operation
like the Bear [she inserts a drawing] . . . you'll probably
tell me I'm a buten *pessimist and a crybaby; but it's a rea-*
son for despair, no? Especially now that you're a complete
optimist after having seen the Rembrandt Elba, every
Lucas Cranach and Durer, and especially all the Bronzinos
and cathedrals. That way I could be totally optimistic and
young forever. You don't know how happy I am that
you've gotten to know the marvelous portrait of Eleanora
of Toledo *and so many other things you tell me about*
[. . .] Now I keep on being an invalid and they'll surely
have to operate later, because although this plaster corset
relieves my backbone, it's of no help for healing the dam-
aged nerves in my leg, and only an operation or the ap-
plication of an electric current (hot) several times
(problematic and not very effective, for the doctor) could
make me better. I can't do either of the two things because

I haven't any money, and so there's nothing to do about it, and you can imagine how sad I'll be. I'm painting the portrait of Lira, buten *ugly. I tried to do it with a Gómez de la Serna background.*

1 5 J U L Y 1 9 2 7 : *I still can't tell you I'm feeling better, yet I'm much happier than before, and I'm so hopeful of getting better for when you return that you mustn't be sad about me for a single minute. I'm almost never discouraged, and I'm not a crybaby very often. On August ninth I'll have been in this position for two months, and the doctor says they'll take an X-ray to see how the vertebrae are, and it's almost certain I'll only have to wear the plaster apparatus till September ninth; after that I don't know what they'll do with me. The X-ray can be taken right here in the house, because I absolutely can't move at all. I'm on a table with rollers so they can take me out in the sun, and you can't imagine how troublesome this is, because I haven't been moved at all for over a month, but I'd be willing to be like this for another six months if it would only give me some relief.*

2 3 J U L Y 1 9 2 7 : *I painted Lira because he asked me to, but it's so bad I don't know how he can tell me he likes it.* Buten *horrible. I'm not sending you the photo, because my papá still doesn't have all the plates in order with the change, but it isn't worthwhile because it has a very pedantic background, and he seems to be cut out of cardboard. I only like one detail (an angel in the background), you'll see. My papá also took a picture of the drugstore-loving*

*Adriana, of Alicia with a veil (very bad), and of the one
that Ruth Quintanilla wanted to be and that Salas likes. As
soon as my papá prints more copies, he'll send them on to
you. He only printed one of each, but Lira carried them
off, because he says he's going to publish them in a new
magazine to come out in August (he must have told you
that, no?). It'll be called Panorama; for the first number
there'll be Diego, Montenegro (as a poet), and who knows
how many more contributors. I don't think it will be any
good. I already tore up the portrait of Ríos because you
can't imagine how much it shocked me. The Flaquer boy
liked the background (the women and trees) and the por-
trait ended its days like Joan of Arc.*

2 AUGUST 1927: *Yesterday was Esperanza
Ordóñez's—Pinocha's—saint's day, and they did some kind
of country dance in my house, because theirs doesn't have a
piano. Salas, Mike, and Falquer were here, and Matilde,
my sister, and some other boys and girls. They took me to
the parlor on my cart and I watched them sing and dance.
I think the boys were quite happy. Lira composed a poem
to the Pinocha girl, and the three talked in the dining
room. Miguel was very generous to the girls with his epi-
sodes, citing Heliodora Valle, López Velarde, and some oth-
ers. I think the three of them are quite fond of Pinocha,
aesthetically speaking, and they've became very good
friends. I, as usual, was a crybaby. Although every morning
I'm taken out into the sun (four hours), I don't see any real
improvement, because the pains are always the same, and*

I'm quite thin; but in spite of this, as I told you in the other letter, I want to have faith. If there's any money, they'll take another X-ray this month, and I'll be able to have some confirmation; if not, I'm going to get up toward September ninth or tenth in any case, and by then I'll know if this corset relieved me or if an operation will be necessary. (I'm afraid). But I still have to wait for quite some time to see if these three months of absolute rest give results or not. I can almost call it martyrdom.

According to what you tell me, the Mediterranean is marvelously blue; will I ever get to know it? I doubt it, because I have very bad luck, but what I wanted most for a long time has been to travel. All I have left is the melancholy of people who read travel books. Now I don't read anything. I don't want to. I don't study German or do anything [. . .] I surely think I'm buten with knowledge. All I see in the newspaper is the editorial column and what's happening in Europe. Nobody knows anything yet about the revolution here. The one right now who seems able to do something is Obregón, but nobody knows anything.

2 AUGUST 1927: *[In a letter to Alicia Gómez Arias.] I keep on feeling bad and no longer talk about anything else, and besides the usual aches and pains, this corset hurts me a lot. Tomorrow it will be two months of wearing this apparatus, and I still don't see any improvement [. . .] Pardon me for writing on this paper, but that's all I have at the moment—all they allow me to have at hand.*

8 AUGUST 1927: *I don't know if I should tell you if*

I'm better or not, because they haven't taken the X-rays, but I still have pains, and day before yesterday I was filled with buten *pain. Lira did me the favor of sending for his papa to examine me with more interest than the others. It would take a long time to explain everything I have, according to him, but I think that what hurts me most is the leg, because the sciatic nerve of the vertebrae is injured. He says I'd have to have thermocauterization, I don't know why. There are about twenty different opinions, but the fact is I'm still hurting, and they're all mixed up [. . .] All the optimism I had is gone, and I'm hopeless again, but now should I really be?*

9 SEPTEMBER 1927: *Coyoacán is exactly the same, everything about it, especially the clear sky at night. Venus and Arturo. Venus and Venus. On the seventeenth it will be two years since our tragedy. I, especially, will remember it* buten *well, although that's stupid, isn't it? I haven't painted anything new, and won't till you come back. Now the September afternoons are sad and gray. In the Preparatory School you used to like cloudy days so much, remember? I've suffered* buten *and I'm almost neurasthenic and I've become very irrational. I'm very much of a coward, believe me, but . . . [. . .] I'm reading* Las ciudades y los años (Cities and Years) *by Fedin, a marvelous talent. He's the father of all modern novelists.*

17 SEPTEMBER 1927: *I'm still sick and almost hopeless. As always, no one believes it. Today is the seventeenth of September, and worst of all because I'm alone.*

*When you come I won't be able to offer you anything
you'd want. Instead of having short hair and being a flirt,
I'll only have short hair and be useless, which is worse. All
these things are a constant torment. All of life is in you,
but I can't have it [. . .] I'm very foolish and suffering
much more than I should. I'm quite young, and it is possi-
ble for me to be healed, only I can't believe it; I shouldn't
believe it, should I? You'll surely come in November.*
17 OCTOBER 1927: *Probably I'll keep on being an
invalid, but I don't know any longer. The Coyoacán nights
are as amazing as they were in 1923, and the sea—
symbolic in my portrait—synthesizes* life *[she crosses out
the italics and continues writing]* my life.

Only by knowing the letters sent to Alejandro Gómez
Arias, with their air of repetitive and alienating desperation
can one appreciate the importance for Frida of Rivera's
bursting into her life. It was Rivera who helped her find the
strength to overcome the anguish and who gave her such
self-confidence that a kind of pride of existence, in spite of
all, started to take hold in her artistic production; this
enabled her to acquire true magnificence in some of her
paintings and drawings.

Frida and Diego were married on 21 August 1929. He
was forty-two and she twenty-two. The wedding took place
in the old Coyoacán City Hall, the witnesses being a wig-
maker and a homeopathic doctor; the judge had been a
friend of Rivera in the School of Fine Arts. In the August 23

number of *La Prensa,* under a large photo of the couple, was
the comment:

Last Wednesday in the nearby village of Coyoacán,
the controversial painter Diego Rivera was married to
Miss Frieda Kahlo, one of his students. The bride was
dressed, as can be seen, in simple street garb, and the
painter Rivera as an American, without a vest. The
marriage was not at all pompous, but carried out in an
extremely cordial atmosphere and with all modesty,
without ostentation and minus ceremonial pretentious-
ness. The newlyweds were extensively congratulated
after the marriage by some intimate friends.

Also figuring on some visiting cards in this Germaniza-
tion of Frida's name, with its added *e.* Isabel Campos,
godmother to the not-yet-born Leonardo, kept one with the
following message: "Pal of my heart, tell me exactly when
you're coming to take a bath so I can pick you up. Pardon
me for not sending you the pants till now, but the cat fancier
hasn't had time to leave them with you. You know that the
two of us—till the end of time. Your powerful pal, Frieda."
On 10 November 1930 Diego and Frida arrived in the
United States, where Rivera would paint murals in San
Francisco, Detroit, and New York, cities where Frida lived
and suffered. A testimony of her reactions is found in two
letters she sent to Isabel Campos.

SAN FRANCISCO, CALIFORNIA, 3 MAY 1931:
Dear old pal: I received your short letter buten *of centuries
ago, but I couldn't answer it because I wasn't in San Fran-
cisco at the time, but farther south, and I had a bunch of
things to do. You can't imagine how I loved getting it. You
were the only friend who remembered me. I've been very
happy except that I've been missing my mamá so much.
You have no idea how marvelous the city is, but I'm not
writing you a lot about it, because I have so much to tell
you. I'll reach the powerful "pueblo" very soon, and I
think that at the middle of my stay I'll be telling you*
butens *and* butens *of things—much gabbing ... I want
you to give lots of love to Aunt Lolita, Uncle Panchito,
and all your brothers and sisters, especially to Mary. This
city and bay are wonderful, but these foreigners don't strike
me well at all; they're very dull people, and they all have
faces like raw biscuits, especially the old women. What is
really fine here is the Chinese quarter; the handful of Chi-
nese are really appealing, and I've never seen prettier chil-
dren than the Chinese in all my life. Well, here's a
marvelous thought: I'd like to steal one of them for you to
see.*

*As to English, I don't even want to discuss it with you,
because I get stuck on the words. I bark out the most essen-
tial ones, but it's extremely difficult to speak the language
well. Yet I do concentrate on understanding, even though
it's with the fiendish salespeople.*

I have no women friends. One or two who can't be

called friends, and that's why I spend my life painting. In September I'll give a show—the first—in New York. I don't have any time, and I could only sell a few pictures here. But it was very good for me to come here anyway, because it opened my eyes, and I saw so very many new and good things.

Since you can see my mamá and Kitti, tell me about them; I'd really be grateful. There's still time to write me a letter (if you want to). I beg you to, because it would make me so happy. Is it too much to ask? Give my regards to everyone, if you see Dr. Coronadito or Landa or Sr. Guillén. To all who remember me. And to you, my beautiful good pal, the usual affection from your chum who loves you a lot. Frieducha.

Kisses for your dear mamá, papá, and brothers and sisters. My address is 716 Montgomery Street.

NEW YORK, 16 NOVEMBER 1933: *My pretty best-loved friend, it's been a year since I've heard a word from you or from any of you people. You can't imagine what a year this has been for me, but I don't want to talk about it; I haven't accomplished a thing, and nothing in the world can console me.*

In a month we'll be in Mexico, and then I can see you and we can have a good long chat. I'm writing this letter for an answer and so you'll give me a lot of news, because although we seem to have forgotten each other, at bottom I always remember you folks, and I believe that you and everyone will remember, from time to time, that I exist, even

so far away. Tell me how Uncle Panchito and Aunt Lolita and all of them are doing, and tell me about yourself and how you're spending the boring Coyoacán days, but when a person is far away they seem so beautiful.

Here in Gringoland I spend my life dreaming of returning to Mexico, but for Diego's work we simply have to stay here. New York is very lovely, and I'm much happier here than in Detroit, but I do miss Mexico. This time we'll stay in Mexico for almost a year, and who knows if we may to go Paris later, but for the time being I don't want to think of what happens later. Yesterday it snowed for the first time here, and very soon it'll be so cold that a person could be carried off by . . . the big reaper. But there's nothing to do about it but wear long wool pants and put up with the snow. At least with those famous long skirts the cold won't go through me so much, but all of a sudden a freezing cold stabs me so sharply that not even twenty long skirts can help. I'm still the same old crazy, and now I'll have to get used to wearing the clothes of long ago, and some gringas even imitate me and want to dress like "Mexican women." But the poor things look like turnips, and the honest truth is they look ridiculous. That doesn't mean I think I'm beautiful, just passable. Don't laugh. Tell me how Mari and Anita and Marta and Lolita are; I know about Pancho and Chato through Carlitos, who suddenly sent me a letter, but I want you to tell me about them all. The other day I met one of the López boys, I don't remember if he was Heriberto or his brother, but we were chatting about you

people with a lot of affection. He's studying at the Univer-sity of New Jersey and is happy there.

Cristi doesn't write me often, but she's busy with the children, and that's why nobody tells me about you folks. I don't know if you see Mati from time to time, now that she lives in Coyoacán, but she doesn't tell me a thing. What have the Canets been doing? Chabela must be enormous by now, and your sister Lolita too; I won't even recognize them when I see them. Tell me if you're still studying En-glish and if not, now that I'll be back I'll teach you, be-cause I "bark" a little better than last year. I'd like to tell you thousands of things in this letter, but if I did it would turn into a newspaper, so I'd rather keep them for when I get home and spit them out then.

Tell me what you'd like me to bring you, because there are so many attractive things here that I don't know what to buy, but if you have some special wish, all you have to do is tell me, and I'll get it for you!

Now that I'll be back, you have to give me a banquet of cheese cake made with squash blossoms and good pulque, because all I have to do is think about it to make my mouth water. Don't feel obligated; I'm only reminding you so you don't forget, now that I'm going back.

What have you learned about the Rubís and all the peo-ple who used to be our friends? Tell me some gossip, be-cause nobody here chats with me, and sometimes gossip is very pleasant to the ear. Give a lot of kisses to Uncle Pan-chito and Aunt Chona too, because she really does like me.

Frida by Frida

*For all of you, but for you especially, here are a thousand
tons of kisses to pass out, but keep most for yourself.*

*Don't fail to write to me. My address is: Hotel Brevoort,
Fifth Avenue at Eighth Street, New York City, N.Y. Your
pal who never forgets you,* Frieda.

In the autobiographical account she gave me in 1953, Frida
said:

*"After spending a year in different corsets, I started
going to the Secretariat of Education, where Diego was
painting his murals. I was tremendously uneasy about
painting al fresco. I showed Diego the work I'd done and
he said: 'Your desire has to take you to your own expres-
sion,' so then I began to paint things he liked. Ever since
that time he has admired and loved me. In a very short
while, I stuck to his kind of painting. Then I tried hard to
work well and make my work clear. My first three paint-
ings were of subjects Diego always used: a woman kneel-
ing, a child sitting on a bench, a woman sitting on a chair
made of palm leaves. My favorite paintings are* La nodriza
y yo (My Wetnurse and Me), El abrazo de amor entre
el Universo, la Tierra, yo y Diego, (The Love Embrace
of the Universe, the Earth, Diego and Me), *and the por-
trait of the engineer Morillo Safa's mother.*

*"My first show was in the Julien Levy gallery in New
York in 1938, and the first picture I sold was bought by
Jackson Phillip, but Morillo Safa got most of my work.*

*"I've done my paintings well, not quickly but patiently,
and they have a message of pain in them, but I think
they'll interest at least a few people. They're not revolu-
tionary, so why do I keep on believing they're combative? I
won't."* [Shortly after this account she began a painting
with a political meaning, but left it unfinished. Paz en la
tierra para que la ciencia marxista salve a los inválidos
y a los oprimidos por el capitalismo criminal y yanki
(Peace on Earth so that Marxist Science may Save the
Sick and Those Oppressed by Criminal Yankee Cap-
italism). *In it Frida painted a self-portrait of her whole
body, with a Tehuantepec skirt and an orthopedic small
waist, throwing her crutches away and holding a red book
in her left hand. Behind her a dove of peace, a head of
Karl Marx, and two powerful hands support her—one of
them with the eye of knowledge in the palm, while the
other kills a bird of prey with the face of Uncle Sam.]*

*"Painting completes my life. I lost three children and
another series of things that would have filled my horrible
life. Painting is a substitute for all that. I think work is the
best thing."*

When she returned from the United States, Frida began to
think about the possibility of painting a mural, and per-
sisted in making rough sketches. She writes about this to
Gómez Arias on 12 October 1934:

"Alex, the lights went out and I don't paint pretty little

things any more. I kept on thinking about decorations on a wall separated by another wall of knowledge. My head is full of microscopic spiders and a great number of tiny little animals. I think we'll also have to build the wall on a microscopic scale, because otherwise it'll be hard to proceed to the deceitful daubing. Besides, do you believe all silent knowledge will fit into such a limited space? And what kind of miniature books will have such small letters made from almost nonexistent type? That is the big problem, and it's up to you to solve it architecturally, because as you say, I can't put anything in order inside the big reality without going directly to the crash, or else I have to hang the clothes out in the open, or place distance in a dangerous and fatal vicinity. You'll save everything with your ruler and compass.

"Do you know I've never seen any forests? How is it that I'll be able to paint a forest background with little animals in a drepa *[great] space?* [Drepa *is* padre *with the syllables transposed, a complimentary term.] Well, I'll do what I can, and if you don't like it, you can proceed to the solid and effective destruction of what has already been thought out and painted. But it'll take so long to finish that we'll never have the time to destroy it or even to think about destroying it.*

"I haven't yet been able to organize the parade of the tarantulas and those other living beings, because I'm thinking that everything will be as if stuck to the first layer of the infinite layers such a wall must have.

"It's done me so much good to see you that I can't tell you how much. I dare to write to you now because you're not here, and because it's in a letter written in this endless winter. I don't know if you'll believe it, but that's how it is, and I can't write to you without telling you so.

"Tomorrow I'll talk to you, and I'd like you to write to me some day, even if only three words. I wonder why I should have to beg you for this, but I surely need your letters; will you write them?"

In 1937 she writes to Gómez Arias: "I'm still sick, and I'll be worse, but I'm learning to be alone, and that's surely an advantage and a small triumph."

Frida's show in the Julien Levy Gallery, at 15 East 57th Street, took place from 1 through 15 November of 1938. André Breton wrote the introduction to the catalogue. These days she writes to Gómez Arias from New York: "Everything was arranged wonderfully well, and I really have indecent good luck. The crowds of people here are very fond of me, and they're all so pleasant. Levy doesn't want André Breton's introduction translated, and that's the only thing that seems a little troublesome, because it's a bit pretentious, but now it's too late to do anything about it! How does it strike you? The gallery is boss and the paintings have been hung very well. See *Vogue:* there are three reproductions in it, one in color I think is quite *drepa;* something will also come out in *Life* this week. I saw two marvelous paintings in a private collection: one by Piero

della Francesca that I consider the very most delightful in the world, and a little Greco—the tiniest I've ever seen, but the most delicate of them all."

Rivera sent the critic Sam A. Lewinsohn a message about Frida's show, dated 11 October 1938, that said: "I recommend her not as a husband would, but as an enthusiastic admirer of her work—acetic and tender, hard as steel and fine and delicate as a butterfly's wing, adorable as a beautiful smile and profound and cruel as life's bitterness."

On 8 December 1939, when Diego was fifty-three and Frida was thirty-two, she wrote to Diego:

> "My child of the great concealer, it's six in the morning and the turkeys are gobbling the warmth of human tenderness. Accompanied solitude. Never in all my life will I forget what you look like. You received me shattered and returned me whole. Where will I set my eyes in this small land? So immense and so profound. There's no more time, there's no more anything. Distance. There's only reality. What was, was forever. What is, are the roots that appear transparent and changed. The tree eternally fruitful. Your fruits shed their aromas, your flowers shed their colors deepening with the joys of winds and blossoms. Diego's name is the name of love. Don't let the tree that loved you so much, that treasured your seed and crystallized your life at six in the morning, be thirsty. Your Frida.
>
> "Don't let the tree for which you're the sun, the tree

that treasured your seed, be thirsty. Diego is the name of
love."

Diego encouraged her to show her work in Paris after New
York, so she reached Paris in 1939, sponsored by André
Breton. There she met Vasily Kandinsky, Marcel Duchamp,
Pablo Picasso, and many other notables in the art world,
who welcomed her enthusiastically. On returning to Mex-
ico, she was surrounded by a whirlwind of political events,
and in January of 1940, she and Diego resolved to proceed
with a divorce. After 24 May, the date on which the attack
on Trotsky's home took place and in which David Alfaro
Siqueiros participated, Frida's house was broken into, and
she was arrested for several hours. On 8 December of that
same year, Diego and Frida were remarried.

In 1943 the industrialist José Domingo Lavín gave
Freud's *Moses* to Frida to read and suggested that she inter-
pret it in images. When the painting was finished, two
years later, Frida explained it like this to a group of friends
gathered together by Lavín:

"I read the book only once, and started the painting
with my first impression. Later I read it again, and I must
confess I found my work most incomplete and quite dif-
ferent from the interpretation Freud analyzes so mar-
velously in his Moses. *But now there's no way to change it*

by adding or subtracting, so I'll describe my painting just as it is.

"The subject in particular is Moses or the birth of the Hero, but I conceived in my own way—a most confused way—the events or images that left the greatest impact on me when I read the book. What I tried to express most clearly and intensely was that the reason people need to invent or imagine heroes and gods is because of their fear—fear of life and fear of death.

"I began painting the figure of Moses as a child; Moses in Hebrew means the one rescued from the waters, and in Egyptian Mose means child. I painted him as many legends describe him, abandoned in a basket floating on a river. Creatively I tried as much as possible to make the basket, covered by an animal skin, bring to mind a womb, but according to Freud the basket is an exposed womb, and the water means the maternal source, that which gives birth to a baby. To focus on that event, I painted a human fetus in its last stage inside the uterus. The horns, that look like hands, are held out to the world. At the sides of the already created child I put the elements of its creation: the fertilized egg and the cellular division.

"Freud analyzes very clearly, but in a very complex way for me, the important fact that Moses was not Jewish. So I only painted a youngster who might represent Moses, like all those who had a similar beginning, according to legend, and later became important people, guides to their countrymen, that is to say heroes brighter than the rest, and that's

*why I painted the eye of knowledge. In this case we en-
counter Sargon, Cyrus, Romulus, Paris, etc.*

*"Another extremely interesting conclusion of Freud's is
that Moses, not being a Jew, gave to the people he chose to
guide and save, a religion that was not Jewish but Egyp-
tian. Amenhotep IV revived the cult of the Sun by taking
as its foundation the ancient religion of Heliopolis. For
that I painted the sun as a center for all religions, as the
foremost god, as creator and reproducer of life. This is the
relationship of the three main figures in the center of the
painting.*

*"Like Moses there have been, and will be, a huge num-
ber of high and mighty people to transform religions and
human societies. It can be said that they are a kind of mes-
senger among the rulers and among the gods they invented
to rule them. There are more of these gods, and naturally
not all of them would fit in, so I arranged on both sides of
the sun those who, like it or not, have some direct relation-
ship with the Sun. At the right those of the West, and at the
left those of the East. The Assyrian winged bull, Amon,
Zeus, Osiris, Horus, Jehovah, Apollo, the Moon, the Virgin
Mary, Divine Providence, the Holy Trinity, Venus, and . . .
the devil. At the left a lightning flash, that is, Hurakán,
Kukulkán, and Gukamatz; Tláloc, the magnificent
Coatlicue, mother of all the gods, Quetzalcóatl,
Tezcatlipoca, the Centéotl, the Chinese dragon god, and the
Hindu Brahma. I have no African god, but I couldn't find
one; I could make a little space for him.*

*"Having painted the gods who don't fit into their respec-
tive heavens, I tried to divide the celestial world of imagi-
nation from the poetry of the earthly world of the fear of
death, then painted the human and animal skeletons you
can see. The Earth cups its hands to protect them. Between
death and the group of heroes there's no division at all,
since the heroes die too and the earth receives them gener-
ously and with no distinction. On the same earth, their
heads painted larger to distinguish them from the common
people, the heroes (very few of them but most carefully
chosen) the transformers, inventors, or creators of religions,
the conquerors, the rebels—that is to say the bucktoothed.
At the right you see Amenhotep, later called Iknaton, a
young pharaoh of the eighteenth Egyptian dynasty, 1370
BC, who imposed on his subjects a nontraditional religion,
one against polytheism and strictly monotheistic, with dis-
tant roots in the cult of On, Aton's religion, that is, the reli-
gion of the Sun. I ought to have given more relevance to
this figure than to any other. Those people not only adored
the Sun as a material being, but as the creator and pre-
server of every living thing, both in and out of Egypt, a
being whose energy is shown by its rays, thus outdoing the
most modern knowledge of solar power.*

*"Then Moses, according to Freud's analysis, gave to his
adopted people the very same religion of Iknaton, changed
a little to be in keeping with the interests and circum-
stances of his time. Freud reaches this conclusion after a de-
tailed study, in which he discovers the intimate relationship*

*between the religion of Aton and the Mosaic, both of them
monotheistic. I didn't know how to translate this whole
part of the book into a painting.*

*"Christ, Zoroaster, Alexander the Great, Caesar,
Mohammed, Tamerlane, Napoleon, and then follows the
'misguided child,' Hitler. At the left the marvelous Nefer-
titi, Iknaton's wife. I imagine that in addition to her ex-
traordinary beauty, she must have been very flirtatious and
a superintelligent help to her husband. Buddha, Marx,
Freud, Paracelsus, Epicurus, Genghis Kahn, Gandhi,
Lenin, and Stalin. The order is askew, but I painted them
according to my knowledge of history, which is also askew.
Between those people and the ones on the hill, I painted a
sea of blood, meaning war. And finally the powerful but
never well-considered common people, composed of all
kinds of little insects: warriors, pacifists, scientists and the
ignorant, monument builders, rebels, flag bearers, medal
wearers, talkers, the insane and the wise, the happy and the
sad, the healthy and the sick, the poets and the fools, and
all the other kinds of people you enjoy who live on this
powerful globe. Only the progressives see themselves a bit
clearly; as for the rest . . . with all the noise, we don't
know.*

*"In the left foreground is Man, the builder, in four
colors—the four races. On the right, the Mother, creator,
her child in her arms. Behind her the Monkey. The two
trees forming an arch of triumph are the new life that al-
ways springs from the trunk of old age. Below in the cen-*

ter, the most important for Freud and many others, is Love represented by the shell and snail, the two sexes, those who contain the ever new and living roots. That's all I can say about my painting."

During April of 1946 she paints *El venado herido* (*The Wounded Deer*) and sends it on 3 May to Lina and Arcady Boytler, with these lines:

Here you have my portrait
so you'll keep me in mind
through all the days and nights
when we are not together.

A portrait of my sadness
on the entire canvas,
but that is my condition
and I've no modesty.

However, there's rejoicing
I carry in my heart
to know that Arcady and Lina
do love me as I am.

Accept this little picture
painted with tender feelings
for all your noble kindness
and your immense affection.

In 1946 Frida returned to New York for some very compli-
cated surgery. On 30 July she writes to Gómez Arias:

> *"I came through the big calamitous operation. Three*
> *weeks ago they did more and more cutting of the bones.*
> *And this medication is so marvelous, and my body is so full*
> *of vitality, that they put me on my poor feet today for two*
> *minutes, and I myself don't believe it. The first two weeks*
> *were filled with suffering and tears; I wouldn't wish those*
> *pains on anyone—they're* buten *strident and perverse, but*
> *this week the yelling lessened, and with the help of some*
> *orange-flavored pills, I survived more or less well. I have*
> *two huge scars on my shoulder blade like this [drawing].*
> *Then they took out a piece of the pelvis to graft it into the*
> *buckbone, which is where the scar tissue left me shaking*
> *but more erect. Five vertebrae were injured, and now*
> *they're going to be like riflemen at attention. Only it's so*
> *hot I don't know what to do. How is Mexico? What's hap-*
> *pening with the people down there?"*

On her return she continued cultivating her friendship with
the Boytlers, and on 31 August 1947 she sent him, a well-
known film producer, this message:

> *"Precious Arcasha, I wanted to make a drawing of your*
> *handsome person, and it came out slightly horrendous, but*
> *if good intentions mean anything, it's full of them, besides*

carrying all my affection. If you're surprised by the eye-symbol I put in the forehead, it's only my wish to express in painting what I think you keep buried inside yourself and very seldom admit: a prodigious imagination, intelligence, and a profound ability to observe life, no? Today on your birthday, and as long as you live, I hope you'll be very happy. Your little fawn, Frida."

In the following years, she enters the hospitals with maddening frequency. This is how she describes that state:

"I've been sick for a year: 1950–51. Seven operations on my backbone. Dr. Farill saved me by giving me back my joy of living. I'm still in a wheelchair and wearing the plaster corset, which is a terrible nuisance but helps my spine to feel better. I have no pain, only fatigue . . . and naturally a lot of despair, a despair no words can describe. Yet I'm eager to live. I've started to paint the little picture I'm going to give to Dr. Farill, and with it goes a lot of affection. I'm very uneasy about my painting, especially how to change it into something useful, because up to now all I've been painting has been an honest expression of myself, but absolutely far from what it could do to help the Party. [She refers to the Communist party; her last membership card is on view in the Frida Kahlo Museum.] I must fight with all my strength, because the little of the positive left by my bad health should go to helping the Revolution, the only real reason for living."

Frida by Frida

On 11 February 1954 she writes in her diary:

> *"My leg was amputated six months ago; I've had cen-*
> *turies of torture and at moments I nearly lost my reason. I*
> *keep on wanting to commit suicide. Diego is the one who*
> *stops me, through my vanity of believing that he might*
> *need me. He told me so and I believe it, but never in my*
> *life have I suffered so much. I'll wait awhile . . . "*

As if she had tried to conjure up her obsession with suicide,
on 24 April 1954 she writes:

> *"I came out safely. I made a promise never to turn back,*
> *and I'll keep it. Thanks to Diego, thanks to Tere [Teresa*
> *Proenza, a Cuban revolutionary and most affectionate*
> *friend, who collaborated with General Heriberto Jara and*
> *Elena Vázquez Gómez in organizing the Mexican Move-*
> *ment for Peace; after that she was Rivera's secretary, until*
> *the painter's death], thanks to Gracielita and the young*
> *girl, thanks to Judith [Judith Ferreto, a Costa Rican, was*
> *Frida's zealous nurse and ultrafaithful friend], thanks to Is-*
> *aura Mino, thanks to Lupita Zúñiga, thanks to Dr. Ramón*
> *Parrés, thanks to Dr. Glusker, Dr. Polo, Dr. Armando*
> *Navarro, Dr. Vargas, and thanks to myself and my enor-*
> *mous desire to live among all the people who love me and*
> *whom I love. Long live joy, life, Diego, Tere, my Judith,*
> *and all the nurses I've ever had and who have treated me*
> *so marvelously well. Thanks to the Soviet people, the Chi-*

nese, Czechoslovakians and Polish, and the people of Mex-
ico, especially the ones in Coyoacán, where my first cell
originated—incubated in Oaxaca in my mother's womb,
because that's where she was born—my mother Matilde
Calderón, dark-skinned Oaxacan bellflower married to my
father Guillermo Kahlo. [At Frida's birth her mother was
apparently in Mexico City.] We're spending a marvelous
afternoon here in Coyoacán in the room of Frida-Diego,
Tere and me, Mrs. Capulina, Mr. Xólotl, and Mrs. Kostic."
[The three last-named were the Mexican hairless dogs who
stayed with Frida for long periods and slept at the foot of
her bed.]

Pictorially Frida represents her pain in all possible versions:
analytic or symbolic, lyrical or burlesque. An extraordinary
portrait painter, the series of her self-portraits is an admi-
rable example of intense expression, but never repeated in
the same aspect. The drawings and paintings, one after the
other, of her melancholy oval face with its meeting eye-
brows, its great shock of dark hair, its aggressively sensual
lips, alert glance, high forehead, and nearly virile shape—
their entirety, as possibly no other work of art in the whole
world, praises the human condition of being oneself and yet
always different, identical and changing.

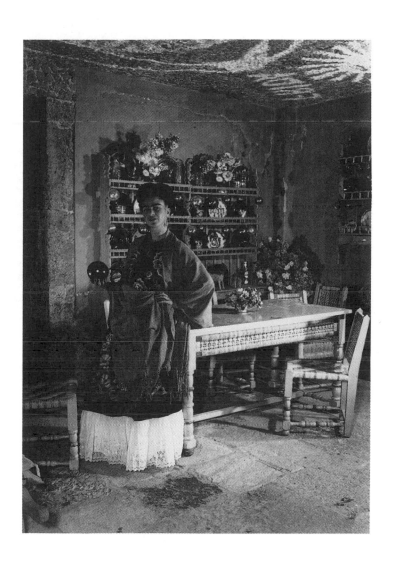

Frida in the dining room of the Coyoacán house.

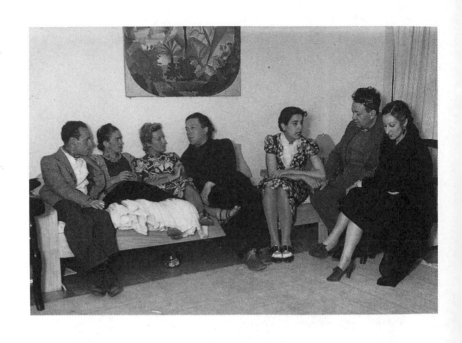

*Frida and, from left, Luis Cardoza y Aragón, Jacqueline
and André Breton, Lupe Marín, Diego Rivera, and Lola
Alvarez Bravo in 1938.*

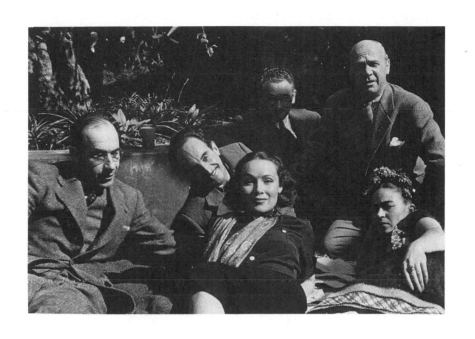

Frida with Dolores del Río, Arcadi Boytler, Adolfo Best Maugard, and two unidentified men.

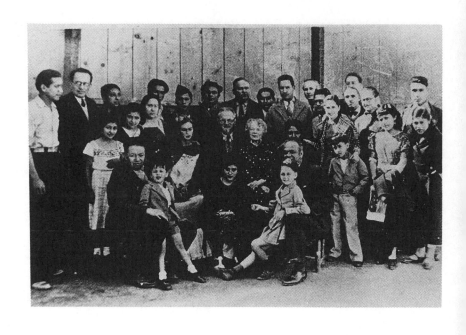

Leon Trotsky between Frida and Natalia Sedova. Diego Rivera is seated at the extreme left.

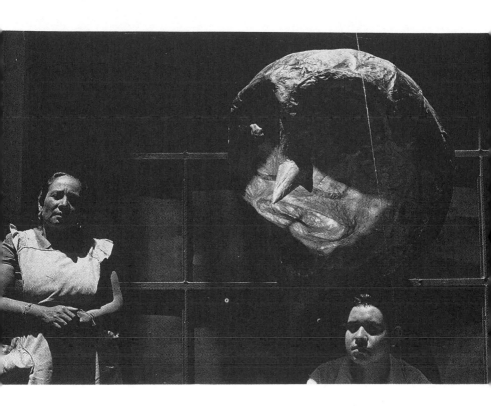

Carmen Caballero, one of Frida's favorite Judasmakers, and her son with the Cabeza ídolo monstruo. *Photograph by Nacho López, 1954.*

*Frida and Diego at the house in Coyoacán. Photograph by
Guillermo Zamora.*

The ceiling mosaic featuring the backward-reading names of Frida and Diego constructed by Diego at the Coyoacán house. Photograph by Guillermo Zamora.

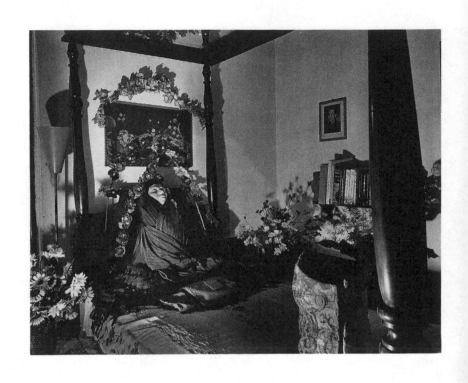

Frida's bed and body cast at Coyoacán. Under the death mask is the urn with her ashes. Photograph by Guillermo Zamora.

Four
Her Years in the Art World

In 1947 the National Institute of Fine Arts mounted an exhibition of forty-five self-portraits by Mexicans from the eighteenth to the twentieth centuries. Only four women participated: María Izquierdo, Isabel Villaseñor, Olga Costa, and Frida Kahlo. On Frida's biographical file card, her birth was recorded as having occurred in 1910, and from then on it was so stated; even Diego Rivera, in a biography written by him for an exhibit of Mexican painting in Lima, Peru, recorded her birth date as 7 July 1910. But it turns out that this chronology was not correct, which became known because of the arrival in Mexico in 1981 of two television professionals from the Federal Republic of Germany: the librettist

Gislind Nabakowsky and the cameraman Peter Nicolay, who were making a half-hour film to be shown on West German television. Wanting this film to show something new, I asked the writer Marco Antonio Campos to accompany the German filmmakers, along with Marco Antonio's godmother, Isabel Campos, Frida's intimate friend and also godmother to the not-yet-born Leonardo; she and Frida had gone to primary school together in Coyoacán, and they had a permanent and very confidential relationship. In the course of the interview, Isabel Campos told the Germans that the date of 1910 was incorrect, because Frida was a year younger than she, and she was born in 1906. It was enough to consult Frida's birth certificate to prove that Isabel was right, but the three-year disparity will have to follow Frida always, since there is little literature to contradict it.

That year of 1910 marked the consolidation of futurism, many of whose postulants influenced Mexican artists, especially Dr. Atl, David Siqueiros, and the stridentists. In 1909 the futurists had published the *First Futurist Manifesto,* but in 1910 they published two important and definitive documents: *Manifesto of Futurist Painters* and *Technical Manifesto of Futuristic Painting.* The first, written in an extremely literary style and loaded with absurd "poetics," was endorsed by the propellant rocket of that movement: the writer (who also wrote poetry) Felipe Tomás Marinetti. Now, in the age of the cosmonauts and astronauts, the writings of that man have acquired a more prophetic and less absurd sense. For example: "Mythology and the mystic

ideal are finally overcome. Let us assist the birth of the Centaur and we will soon see the first angels fly." And further on, Marinetti shouted: "Let us leave knowledge as if it were a horrendous shell, and let us rush, like fruit fermented with pride, into the immense and twisted mouth of the wind. Let us be a pasture of the unknown, not out of desperation, but only to fill the deep wells of the Absurd to overflowing." Then came some sentences that made history and still do:

> We say that the world's magnificence has been enriched
> by beauty, the beauty of speed. A race car, its radiator
> adorned with thick tubes like snakes with explosive
> breaths, an automobile that roars, that seems to run on
> a bullet shot, is more beautiful than the Victory of
> Samothrace. We want to praise the man at the steering
> wheel, for his ideal axle crosses the Earth, she herself
> hurled into the race over the circuit of her orbit [. . .]
> Beauty no longer exists apart from struggle. No work
> that is not aggressive can be a work of art [. . .] We are
> on the highest promontory of the centuries! Why
> would we look back if we want to tear down the mys-
> terious gates of the Impossible? Time and space died
> yesterday. We now live in the absolute, because we have
> created eternal omnipresent speed [. . .] We want to
> destroy all kinds of museums, libraries, and academies
> [. . .] Museums are cemeteries, truly identical because
> of the sinister promiscuity of so many bodies that do

not know each other! Museums are public dormitories
in which one rests forever beside odious or unknown
beings! Museums are absurd slaughterhouses of
painters and sculptors who are murdering each other
ferociously with blows of line and color all along the
disputed walls! They should be visited on a pilgrimage
once a year, just as we visit the cemetery on the Day of
the Dead—this we concede. Let us go once a year to
leave a floral wreath at La Gioconda—that we con-
cede.

And with the euphoria, reaction, fascism, obscurantism,
aggressive and voracious imperialism that he would change
into tragic reality then and now, the Italian painter de-
manded: "Let's go! Let's set the library bookshelves on fire
and divert the course of the canals to flood the museums.
Oh, the joy of seeing the glorious old stuff mangled and
discolored and drifting down those waters! Seize the picks,
axes, and hammers and destroy the revered cities, destroy
them without pity!" Would Marinetti have supposed that
his appeal would find such a forceful answer—as ample
and grandiose as the fire of London, the bombing of Dres-
den, the destruction of Hiroshima, the environmental kill-
ing in Vietnam, the genocide in Beirut? Because this decla-
ration written before the First World War should have
waited for the Second to see museums and libraries turned
to dust, and the Vietnam War to find cities like Hue de-
stroyed "without pity"—not with hammers, axes, or picks,

but with high-powered bombs of diverse effect. It should be made clear, to avoid all error, that Italian fascism in power gave no reward to the futurism established in one sector of the intellectual vanguard. It rewarded a warmed-over, empty, and pompous neoclassicism, or an obvious naturalism like the one practiced by Afro before his success with that celestial or atmospheric abstractionism that was so influential in another unlucky personality of Mexican painting: Lilia Carrillo.

The Manifesto of the futurists was signed by five talented painters: Boccioni, Carrá, Russolo, Balla, and Severini. Vehemently protesting and basically moralizing, like all futurism, it contained the expression of a need.

We rebel against passive admiration for the old—the old statues, the old objects—and against enthusiasm for all that is termite-ridden, dirty, corroded by time, and that we consider unjust and criminal; against the usual scorn for everything young, new, and throbbing with life [...] In the country of traditional aesthetics, brilliant and novel inspirations take flight today. The only vital art is that which finds its own elements in the environment surrounding it. As our ancestors found art material in the religious atmosphere that dominated their souls, so we must find inspiration in the tangible miracles of contemporary life, in the metallic net of speed enveloping the Earth, in the transatlantic liners, in the *Dreadnought,* in the marvelous flights piercing

the skies, in the somber boldness of the submarine nav-
igators, in the spasmodic struggle to conquer the un-
known. Can we remain insensitive to the frenetic
activity of the great capitals?

Although born at the same time as futurism, not even by
instinct or intellectual desire did Frida Kahlo belong to that
current. The idea of flight, present in many of her diary
pages, did not identify her with airplanes, but with the
freedom of spirit and the unlimited reaches of fantasy.
"Why do I want feet, if I have wings for flying?" she once
wrote. In Frida's work there is a great determination for
solid reality, a phenomenon so sincerely shown in her paint-
ings that many of the absolutely Mexican qualities of her
images are generalized.

The common denominator of surrealist painters is their
keen doubt about foreign traditions and their desire to
create unmistakably personal imagery. Frida owes much to
the charming photographic portraits painted in Mexico in
the second half of the past century, as well as to the *retablos*
that thank God or the saints for a continuation of life in
spite of the most horrendous misfortunes; and—more than
to anything or anybody—she owes to popular Mexican art
the manorial pride shown in fragile materials, in the monu-
mental force developed in small dimensions, and in ironic
disorder before the macabre. These contradictory factors
are the best proof of her rebellion against adversity. Life and
work as affirmation and reaffirmation of the living.

The idea that the origin of art is found in illness or in nervous irritability has its origin in the romantic, and in this respect one must remember that the horizon of the modern in art opens with romanticism and broadens with the vanguard movements at the close of the nineteenth and the first decades of the twentieth centuries—vanguards that have sprouted in the warmth of technical and scientific development. The rule that the sources of creation are found in the depths of the soul, in that dark and mysterious region from which emerge myths and religious faith, is also of romantic origin. There have always been neurotic artists, but the state of the neurotic spirit characteristic of Romanticism only acquires real significance when art stops being a public matter. The feeling of its "uselessness" awakens in artists an exaggerated concept of themselves as well as a feverish eagerness for originality and an excessive narcissism.

Frida was seventeen, had suffered the slight results of polio, and had not yet had the accident that would condition her existence, her temperament, and her art, when André Breton published the first *Manifesto of Surrealism*. In 1938, with a memorable article dedicating the theoretical and international support of surrealism to her, Frida Kahlo de Rivera (Breton's writing gave her that title) was pigeonholed among the surrealist painters, a qualification authenticated during the International Exhibition of Surrealism, held in January and February of 1940 in the Gallery of Mexican Art. Organized by André Breton, Wolfgang Paalen, and Cesar Moro, it contained "prophetic clocks, fifth di-

mension perfume, radioactive picture frames, and scorched invitations," in addition to "the great nocturnal sphinx."

The Spanish painter and critic Ramón Gaya, there at the opening, wrote in the second number of the magazine *Romance* of 15 February 1940:

> To inaugurate its new location, the Inés Amor gallery has gathered some works of Paris-influenced artists who, together with some others from Mexico, form a most interesting International Surrealist Exhibition. Most interesting and . . . nothing else. Anachronistic indeed, and that's why it was perhaps so interesting to us, since its anachronism, distance, and remoteness allowed us to find what we had already been feeling and thinking about surrealism, though a bit vaguely. At the opening day's reception, while it was impossible to see the paintings on view, we did see and understand better than ever, however, what surrealism is; we discovered that this show, as someone said, is now too late to be in present time, and too early to be history. In a word, it's old, and oldness cannot—must not—exist in art. Therefore the whole exhibition may give the impression of rubbish, residue, dusty objects, and ashes. The only thing alive in it is the personality, the powerful spirit, of such-and-such a painter revealed in his or her work—not thanks to surrealism, but leaping out of it as if to save the artist from his or her own ruin. [. . .] After the pretty, inane, and weak appearance of the

Great Nocturnal Sphinx, everything developed into the
most amiable, affable, nice, bourgeois, and normal of
surroundings. Therefore nobody felt truly surrealistic.
It all had the character of a very courteous visit that
one might pay to surrealism, but not of a most affec-
tionate and vehement encounter. [. . .] Not even did
that gentleman who felt insulted lash out furiously
against surrealism. No, surrealism has already lost its
indignant enemies, doesn't injure anyone, has changed
into something almost rose-colored, into something
chic, into something in good taste. And when a move-
ment of the violence, exaggeration, and extremism of
surrealism loses its detractors, it means it has also lost
its force, its reason for being [. . .] Surrealism has
merely died as a struggle, as a school, as an injudicious
action, as a warning; it has died, in short, as a move-
ment that has fulfilled its duty. The struggle has
ended—ended and been won, because it gained things
for art that may never be lost. And, unnoticed, it will
leave us with an essential surrealism—profound, with-
out pageantry or shouting, and very much within us.
But something similar happens in all wars. With so
much fighting and suffering, the war and the fighters
and all the people end with an intoxication that begins
to confuse the war itself with its objective. That's why
we have such a bad impression today when we run into
a poet or painter who still practices orthodox surreal-
ism. It is as if he hadn't realized that peace has begun,

and he is still carrying his gun. The bigotry and compliance of those poets and painters show us that they never truly learned about surrealism, and that enrollment in its ranks is due first and foremost to the belief in all candor that they were fighting for a completely new cause. It shows us that their bigotry was not a deep conviction, but a stupid snobbism. [...] Today the ladies who leaf through *Vogue,* the gentlemen of good taste who take charge of surrealistic household furnishings, plod along, naturally, without knowing anything real about surrealism, but it *sounds* to them like a *nice* thing. Since those people are enchanted by that rose-colored surrealism, they'll at least know how to tolerate the other, the essential, the profound.

The comments of Ramón Gaya, made in the heat of events, is indispensable testimony because of his just positioning of the event, and even more so since the International Exposition of Surrealism has been made too much of a myth. In the overevaluation process, events and their protagonists have lost some historic reality.

This show gathered together sculptures, drawings, photos, reproductions, paintings, rubbings, X-rays, collages, objects, illustrations, and reproductions by Hans Arp, Hans Bellmer, Denise Bellon, Victor Brauner, Manuel Alvarez Bravo, Serge Brignoni, Graciela Arcanis-Brignoni, Giorgio de Chirico, Salvador Dalí, Paul Delvaux, Oscar Domínguez, Marcel Duchamp, Max Ernst, Espinosa, Gordon On-

slow Ford, Esteban Frances, Alberto Giacometti, Humphrey Jennings, Frida Kahlo, Wassily Kandinsky, Paul Klee, René Magritte, André Masson, Matta Echaurren, Joan Miró, Henry Moore, César Moro, Meret Oppenheim, Alice Paalen, Wolfgang Paalen, Roland Penrose, Francis Picabia, Pablo Picasso, Man Ray, Remedios, Diego Rivera, Kurt Seligman, Eva Sulzer, Yves Tanguy, Raoul Ubac, De la Landelle, Agustín Lazo, Manuel Rodríguez Lozano, Carlos Mérida, Guillermo Meza, Moreno Villa, Roberto Montenegro, Antonio Ruiz, and Xavier Villaurrutia. Of the Mexicans, only Frida, Rivera, and Alvarez Bravo were cataloged in the international section. The rest were grouped as "Mexican painters," after the drawings by the insane, pre-Hispanic art, the popular masks of Guadalajara and Guerrero, and after what was termed "savage art," which included masks of New Guinea, New Mecklenburg, and African sculptures. A nostalgic mixture of objects the emigrants from the Second World War had brought to Mexico.

The artist who appeared in that catalog with the single name Remedios was then the wife of the poet Benjamín Péret; she later became the famous painter Remedios Varo. Alice Paalen developed her own personality in Mexico as Alice Rahon.

Frida participated in that exhibition with the well-known *Las dos Fridas* (*Two Fridas,* 1930) and the very handsome *La mesa herida* (*Wounded Table,* 1940). She had formerly shown her paintings in important collective exhibits such as the opening of the Department of Social Action Art Gallery of

the National Autonomous University of Mexico, headed by Julio Castellanos. Together with the works of José Clemente Orozco, David Alfaro Siqueiros, Diego Rivera, Fermín Revueltas, Gabriel Fernández Ledesma, Dr. Atl, Antonio Ruiz, Roberto Montenegro, Luis Ortiz Monasterio, Mardoño Magaña, Germán Cueto, Guillermo Ruiz, María Izquierdo, Juan O'Gorman, Federico Cantú, Jesús Guerrero Galván, Julio Castellanos, Agustín Lazo, Carlos Mérida, Rufino Tamayo, Carlos Orozco Romero, and Alfredo Zalce, Frida showed the painting *Arbol genealógico* (*Genealogical Tree*), an oil of 1936.

That show was considered a real success in the art world, and at the opening of the Art Gallery on 23 September 1937, Salvador Azuela, the head of the Department of Social Action in Mexico's National University, gave a talk (published in *University,* number 21, volume 4, October 1937. This was a "monthly of popular culture," whose editor was Miguel N. Lira), in which he said that "another step [has been taken] to overcome the teaching of purely professional preparation and to replace it with culture, whose trial is always resolved by a creative act."

An essential aspect of man's spiritual formation is the education of the emotions. If any social influence is endowed with emotional content, it is aesthetic work. Therefore no learning center—except a university—can be free from this way to form a human being. The strongest manifestation of our people's personality be-

gins in our contemporary pictorial movement—one in
which the deep sense of events, known under the
rubric of the Mexican Revolution and oriented toward
a search for our own expression, is best acquired.

In this opening of its Art Gallery, it is important to
clearly define the university's interpretation of the new
work our institution is carrying out. The Gallery's stan-
dards will be the postulates the university esteems as
basic to its spiritual architecture. The National Univer-
sity emphasizes what is generally known as autonomy,
autonomy as the ability for self-determination in the di-
rection of the Republic's higher culture. If this means a
particular sphere of influence over against public
power, it does not imply the concept—nor its realiza-
tion, disregard, or negative activity—of public service
in the higher forms of the country's education. Auton-
omy also in all kinds of political, economic, religious,
artistic, and intellectual organizations. The rationaliza-
tion of how a university functions, so conceived, has
been integrated into an atmosphere in which nobody
can be coerced, one that guarantees the broadest pos-
sibility of faithful adherence to, or rejection of, the doc-
trinal positions that argue the trend of the
contemporary spirit so fully received in this house.

The University's principles, the very nature of the
Institute, presuppose a political task. Of course the
University does engage in politics, but it does so in a
Platonic and Aristotelian sense of the term, by fulfilling

its duty of cooperating with public welfare, of intervening in the moral orientation of city life—not by carrying out electoral, factional, or personal politics.

In this Art Gallery, then, the criteria of a greater sympathy for all artists will prevail, without restrictions of clerics or schools. The Gallery's only limit, besides that of artistic worth, will be the very one the University has imposed, that of not being an instrument for carrying out the purposes of militant politics.

With these brief words I must say that the University today does pay homage to the most respectable kind of artist: to the outlawed, unadaptable, persecuted, the one who fails to understand his art as dispossessed of transcendental permanence, the one who declines to play the role of courtesan in a poor attitude of flattery to the powerful by tying his work to immediate success. We must express our agreement with the 'great class of proud artists who know nothing about master or humility.'

The National University of Mexico hands over this Gallery to generosity, comprehension, and the moral class of Mexican artists. As the Gallery opens, I must say, in the name of the institution, that our vote is for the work of the Republic's artists to be more Mexican, to the extent of being more universal and human. Because what is every university, and what have they always been, but an aspiration for universality?

In November of 1938 Frida and Diego headed a list of
nearly a hundred signatories in a document addressed to
"the workers of Mexico," to let them know about the
defacing of Juan O'Gorman's murals in the waiting room of
Mexico City's Central Airport. For its importance as testi-
mony from one of the country's critical moments, it must be
remembered in its entirety, just as it was printed in the third
issue of the magazine *Clave* on 1 December 1938, "a Marxist
podium" on whose editorial board sat Adolfo Zamora, José
Ferrel, and Diego Rivera.

By the express orders of the Undersecretary of Com-
munications and Public Works Modesto Rolland, and
of the head of Civil Aeronautics General L. Salinas, an
act of vandalism was committed in the destruction of
Juan O'Gorman's paintings in Mexico City's Central
Airport. This destruction was carried out brutally and
in a form worthy of the action of a totalitarian head of
state, with all the fury and hatred of culture and art of
which an ignorant autocrat is capable, disregarding the
constitutional precepts of individual guarantees and
permitting himself the luxury of making fun of free-
dom of expression, established by the centuries-long
struggle of the masses. So it seems that the hand of Un-
dersecretary Rolland is directed by Hitler.

Why did Mr. Rolland and company do such a thing?
Rolland himself answers this question in his official

November 7 letter, number 11/1905, to the painter
O'Gorman, saying verbatim: "Having permitted the
hanging of pictures everywhere with such flagrantly
immoral titles, and also having painted heads resem-
bling state government officials whom there is no rea-
son to insult the way you have done, we are telling you
once again in writing that if you are not ready to paint
out everything undesirable in these pictures, we our-
selves will have to do it at your expense."

One of the signs Mr. Rolland ordered removed was
the following: "With the Communist revolution the
proletariat has nothing to lose but their chains, and in
exchange they have a world to gain." (Karl Marx and
Frederick Engels, from the *Communist Manifesto*). Our
illustrious gentleman judged this quotation immoral,
which does not surprise us in the mouth of the man
who was the flag-carrying apostle of the only tax on
rent; but what is not explained is how General Cár-
denas tolerates this distinguished gentleman in his cabi-
net.

By what you do to the heads resembling chiefs of
state you have no reason to insult, we ask you, Don
Modesto, why you came forward in a diplomatic com-
plaint? For fear of your real bosses, who are Hitler and
Mussolini, who make you so uneasy, rather than
Lázaro Cárdenas and Francisco J. Mújica? Do you
think there might be some foreign minister as intel-
ligent and clear-sighted as you who would protest to

Mexico, knowing that Hitler had no beard and Mus-
solini no horns? Do you consider, Mr. Undersecretary,
that art in Mexico should be under the intellectual pro-
tection of one of those chiefs of state you find so accept-
able?

Why did you not let the painter O'Gorman, whose
signature appears on the painting, be responsible for his
own actions? Is it that you, Mr. Undersecretary, are
afraid of losing some underling subordinated to subfas-
cism, so that the Mexican underbourgeoisie bound to
imperialism can try to hand over Mexico to the power
of the totalitarian countries?

Do you think there is no reason to insult whoever
has ordered the burning of the books of Schiller,
Heine, Marx, and Engels; or the man who has been
paid millions of marks for assassinating a diplomat; or
the persecutor of the genius of modern physics, Ein-
stein; or the persecutor of the great artists Paul Klee,
Kandinsky, and George Grosz; or the one who has for-
bidden the painting of that glorious old man Liber-
mann; or the restorer of the religion of Thor and
Wotan, a cultmaker of the barbarian age who would
assure a very quick end to the race of German philoso-
phers who have enlightened the world, and who would
also be assured that the workers no longer need to
think because the Nazi minister of propaganda would
do it for them?

Possibly the modest engineer Rolland, inventor of a

famous tortilla maker and a way to make Mexican soil more productive by hanging basketfuls of earth in the trees for planting potatoes, has become bewildered by the subpost he fills now, remembering that he bears the name of the heroic and celebrated French peer who split a huge rock in Roncesvalles with his sword before he died. Is our modest inventor Don Modesto really a descendent of Charlemagne's Roland?

Because of the workers reduced to slavery in the concentration camps, vilely tormented and assassinated, the Mexican workers must see what it means when an undersecretary of the Mexican state declares himself from the officious defensive power of the workers' enemies, and speaks in writing in the name of the Mexican state and in the tone of a capitalist who tramples on the most elementary rights of self-expression. The proletariat must see in the actions of the knight Rolland—unfortunately backed until now by the silence of the executive, today Rolland's boss and one of the founders of the Communist party, Francisco J. Mújica—the actions of an enemy of the workers who behaved with vandalism, typical of totalitarian police power, when he destroyed the Central Airport paintings of a Mexican artist who supported working-class interests.

Together with Diego and Frida, the signatories were Roberto Montenegro, Antonio Ruiz, Manuel Rodríguez

Lozano, Carlos Orozco Romero, Ernesto García Cabral, Jesús Guerrero Galván, Fidencio Castillo, Francisco Zúñiga, María Izquierdo, Gabriel Fernández Ledesma, Feliciano Peña, José Chávez Morado, Raúl Cacho, Enrique Yáñez, Julio Prieto, Manual Alvarez Bravo, Octavio Barreda, Octavio Paz, Ermilo Abreu Gómez, Elías Nandino, Julio Castellanos, Rosendo Salazar Alamo, Neftalí Beltrán, Rodolfo Usigli, Salvador Novo, Germán Cueto, Carlos Chávez, Julio Bracho, Andrés Henestrosa, Rafael Solana, Agustín Yáñez, and Frances Toor. Rufino Tamayo from the United States was added to the protest.

But Cárdenas's governmental policy toward the arts should really not be characterized by that serious incident. Cárdenas had not thought of support for the development of the arts (as occurred later, in the time of Miguel Alemán) as a mechanism more or less arbitrarily practiced on behalf of the powerful, but rather sought a voluntary balance between populist demagoguery and art for the elite, simultaneously applauding the formation of extremely valuable private collections.

Cárdenas refused to be the obligatory model of official commissions, as would occur in Adolfo López Mateos's administration, in the many murals painted in the buildings of the National Institute of Mexican Youth, a branch of the Secretariat of Public Education, where the president always appeared to be offering the benefits of culture and sports, by means of paintings, to the girls and boys of the common people. During his term of office the emphasis in artistic

production was placed on its social impact. Cárdenas told the artists that "in a country where the percentage of illiterates is very high, where the working class is organizing, where the struggle against imperialism and for economic freedom is soaring, at the same time as attempting to regain possession of the destitute and protect freedom of expression, there are many roads of culture to benefit the majority; travel them."

If freedom of expression was brutally attacked in Juan O'Gorman's murals, this was due to—or was one of the many consequences of—the boycott imposed on Mexico by petroleum expropriation. To survive, Mexico had to sell its oil to Hitler's Germany.

We could place the activities of the League of Revolutionary Artists and Writers (LRAW) in a totally inverse order. Although founded in 1933, it was between 1935 and 1938 when it was most productive. How to forget that it was in 1937 when Leopoldo Méndez and his friends founded the Workshop of Popular Graphics where, in addition to a lively production of posters that covered and politicized the population of the capital and the entire country, the formidable portfolio *La España de Franco* (*Franco's Spain*) was published in 1938. It contained fifteen lithographs of the most profound social expressionism carried out by Raúl Anguiano, Luis Arenal, Xavier Guerrero, and Leopoldo Méndez. Its prologue was fluently written, in the artistic manner of the Cárdenas period:

A group of democratic and revolutionary Mexican art-
ists, naturally on the side of republican Spain, needed
to express their full adherence to the heroic Spanish
people, by accomplishing what they possibly could: an
album of lithographs printed in their studio. *La España
de Franco* gathers together an ironic but essential
version—at times dramatic—of factual documents in
Franco's Spain, although we know that it was tempo-
rarily dominated by Germany and Italy. The artists
who drew on stone the pictures shown here want to
take advantage of the present occasion to state their de-
cision to struggle and continue struggling against the
fascist assassin of popular freedoms.

A year later, in 1938, the Secretariat of Public Education
commissioned Leopoldo Méndez to put the album together,
with seven lithographs, under the common title *En nombre
de Cristo...* (*In the Name of Christ*), and the great artist
collected seven accusations with which he unleashed an
insuperable graphic force. Here Méndez let Orozco's influ-
ence flower in his spirit, and his inventiveness yielded a
great and expressive richness, which was placed with deep
conviction at the service of the struggle against *cristero*
reactionism. This movement murdered without pity the
teachers sent by Cárdenas's government—with neither cat-
echisms nor religious fanaticism—to the farthest reaches of
the country.

Her Years in the Art World

It was in January of 1937 when, with the widest support from the authorities, LEAR was able to assemble in Mexico City the National Congress of Artists and Writers, which the most outstanding intellectuals of the neighboring countries attended as observers and special guests, including United States representatives, Waldo Frank among them. One of the opening-meeting speeches was by the Cuban Juan Marinello, who clearly captured the spirit of the congress.

> The thoughtful and sensitive men who are going to debate in this Congress are already on the margin of justice, and not because they belong to one party or are all of the same belief. This Congress does not hold one definite political theory, nor did those who called it together demand any party following. All that the Mexican League of Artists and Writers asks—or can ask—of the participants is simple human honesty. LEAR demands nothing more, because it knows that at the height of the dilemma reached by the world's struggles, dominant honesty is enough for coming to just decisions. At all times and on every occasion, two opposite and decisive currents have battled in human groups: the one that wants to maintain unjust limitations, and the one that tries, by reason and by action, to topple those limitations. But only in our days have men—all men—had a clear understanding of reason and of the operation of these forces. The great Ameri-

can José Martí, in one of his astonishing predictions, said that genius was passing from the individual to the collective. If genius is the sum of science and consciousness that forecasts the future, if genius is the penetrating impulse determining our tomorrows, then the Cuban Liberator wisely stated that it is the masses who now consciously bring about the transformation of the Earth. And if the world's future, man's good and evil, are no longer treasuries of the erudite or predictions of the redeemers, can an honest intellectual remain on the expectant shore, or join his career to those who try to keep tomorrow from coming?

In that opening session of 17 January 1937, it was Waldo Frank who pointed out the scope of Cárdenas's political efforts. "Truly, only one nation in the Western Hemisphere has been sound enough and has had the vision and generous power to be frankly on the side of humanity in the battle waged by Spain for us all. That country is Mexico, and for that single action, as well as for the carrying out of its social program, Mexico marches in the vanguard of the American nations."

But that LEAR congress did not only discuss politics and war. From its rostrum the painter, scenographer, and museum expert Carlos Mérida put forth the idea of what would later gel as the movement of modern Mexican dance, which defined its form in the last year of Cárdenas's government.

In the dance culture of every people in its most primitive or most complicated choreographic manifestations, we always find the characteristics of a social state more precisely than in other artistic expressions. So dance has a special essence, an absolute autonomy, and it stands alone. It lives in time and space. It is bound to time by music and to space by its creative qualities. Dance must say what music, painting and poetry cannot say, because it is a combination of them all, a perfect form of expression complete in itself. The human body is the vehicle, its content par excellence."

And Carlos Chávez, affirming the roots of new orientations in musical creation, declared:

There is no sense in making a new instrument by considering an old music; today's traditional music is perfectly satisfied with its own present-day instruments. Just as the new electronic sound devices were unforeseen, new instruments will bring about a new kind of unexpected music. Just as physicists invented a new medium, musicians will compose a new kind of music. The artist must work in the present, and he has only two means of doing so—by delving deeply into history to extract from it the experiences of past generations, and by being well acquainted with his present world and all its developments and resources, in order to be able to basically interpret his own needs.

It was in the Cárdenas administration that the exhibition gallery in the Palace of Fine Arts was strengthened. Its construction was started in 1904 and ended between 1932 and 1934, the latter year that in which Orozco and Rivera painted the second floor murals. Within their ideologically peculiar styles and conceptions, both achieved a strong revolutionary content. Orozco criticized those who took advantage of the initial chaos of structural change to deceive the people, especially the working class; and Rivera praised the mastery of nature to be acquired by man in a society structured by dialectical-materialistic meaning, in contrast to the irrationality and injustices of the imperialist stage of capitalism. This mural had been painted originally in New York's Rockefeller Center in 1933, but Nelson Rockefeller ordered it destroyed because the figure of the revolutionary leader was represented by Lenin.

It was President Cárdenas who commissioned Rivera in 1935 to paint the mural on the left of the National Palace stairway, the one entitled *El México de hoy y del mañana* (*Mexico Today and Tomorrow*). This represents the most ferocious criticism made by any mural of the weaknesses of the Mexican Revolution, beginning with the compromises of Plutarco Elías Calles, who appears here as a prominent member of the counterrevolution. At the right of a miserable peasant family gathering a meager harvest, are Frida and her sister Cristina. On Frida's chest is a medallion showing a red star and a hammer and sickle, and the two women are aided by Cristina's children, Isolda and Antonio

Pinedo, in proselytizing on behalf of the Revolution by teaching the texts of Marx and Engels to the proletarian and peasant youth, and against the religious fanaticism that causes disunity.

Before, in 1928, Diego had painted Frida on one of the panels of *Corrido de la Revolución* (*Ballad of the Revolution*) in the Secretariat of Public Education, with the five-pointed star on the left side of her shirt, as she distributes guns to the people, who are rising up in arms to complete the socialist revolution. In 1930 he makes a lithograph of a nude Frida seated modestly on a bed. In 1945 he paints her, in the Tenochtitlán plaza of the National Palace, as a seductive Hetaira provocatively showing her beautiful tatoos to the old priests, who look at her lasciviously as they offer her the arms and legs of human beings in payment. The last time Diego put Frida's figure in a mural was on the movable panel *Pesadilla de guerra, sueño de paz* (*Nightmare of War, Dream of Peace*), in 1952. In a wheelchair, beside other Mexican fighters for peace, Frida appears collecting signatures for the first Stockholm appeal. One of the most beautiful portraits Diego painted of her was the mythical Frida in *Sueño de una tarde domenical en la Alameda Central* (*Dream of a Sunday Afternoon on the Alameda*) of 1947. To the right of Frida is José Martí, the great Cuban, holding up his bowler hat in greeting. In front of her Diego himself as a child, with short pants, striped stockings, high shoes, and a bagful of frogs and other small animals, led by the hand by

José Guadalupe Posada's *Calavera catrina* (*Elegant Skull*). Behind the smiling, pop-eyed chubby boy is Frida, dressed in her Tehuantepec skirt, her left hand holding a small sphere with the ying and yang symbol, the beginning of life. Another portrait of Frida was painted on the panels Rivera made in 1939 for the International Golden Gate Exposition in San Francisco, with the theme "Art in Action." Here Frida appears as a symbolic figure of the artist of the South. Close to her is the portrait of Dudley Carter symbolizing the artist-engineer and of Paulette Goddard as the young woman of the North.

In 1928 Frida painted her sister Cristina, who died on 7 February 1964. Cristina was also Diego's favorite model; her figure inspired two of the monumental nudes adorning the hall of honor in the Secretariat of Health. In 1929 she posed first for the figure of Knowledge, surely qualified as idyllic and malicious. Later her small body, with its rounded and gentle forms, was represented in Life, the figure looking down from the hall's ceiling. It has been well pointed out that there is nothing pornographic or voluptuous in the curves of those nudes, in those immodestly painted bodies that symbolize the knowledge of life, health, strength, purity, and continence.

Of the four Kahlo-Calderón sisters, Cristina was the one who was closest to Frida. She cared for her with unlimited devotion, easing her many moments of incurable dejection. With the years, however, Cristina's altruistic temperament

was more the result of charity, which she thought of in a singular way and carried out as a voluntary obligation, counting on the support of the financier Ricardo J. Zevada.

In the last days of her life, Cristina lived as a recluse, perhaps troubled by the unpleasantness she felt when Diego Rivera had the old Kahlo house in Coyoacán dedicated to the exclusive memory of Frida, changing it into the museum that bears her name.

As to freedom of expression in President Lázaro Cárdenas's administration, we must make note of the fact that he did not plaster over the mural *México de hoy y del mañana* (*Mexico Today and Tomorrow*), which in judging the Mexican Revolution was in fact judging him; and here follows that criticism–self-criticism as a warning to all who occupied the presidential chair from 1935 onward. The mural seemed to give an anticipated answer to, or be an illustrative support of, the declarations made by General Plutarco Elías Calles and published in the Los Angeles Times on 2 June 1936: "I do not agree with the present communist tendencies in Mexico [...] I am not afraid of new ideas, but I do not believe that the principles upheld by the present government would be applicable to my country. [...] One member of the Mexican government's present cabinet has stated that industry would be controlled by the workers [...]. This would bring about a serious reaction, a fascism with dictatorial militarism, and all kinds of dictatorships are wrong."

At the beginning of 1939, the Mexicans who had fought in Spain started to return, among them David Alfaro Siqueiros, lieutenant colonel in the Popular Army of the Republic. Worried by the circumstances he noticed in Mexico, Siqueiros signed the following statement in the magazine *Futuro,* edited by Vicente Lombardo Toledano:

> Not in France or England or Canada or the United States (countries we traveled through recently on our way back to Mexico) have we found a more vulgar and outrageously hypocritical press than the seditious press of Mexico. Its selling out to the retrogressive faction of the Spanish colony, and to the fascist agencies of Germany and Italy, reaches the limits of veritable treason against Mexican nationality itself. On the other hand, the forces of progress and freedom are in absolute and very grave physical inferiority regarding their means of publication.
>
> The ministries and all government dependencies in general are filled with counterrevolutionary ambushes that unquestionably conspire against General Cárdenas's own government.
>
> The bureaucracy's displaced persons, the losers from among the political trash, the "deboned" of all political tonalities, are uniting and publicly organizing to flagrantly offer their mercenary services to Mexico's foreign conspirators and to the conquerors of her people.

In the university, in all sectors of public education, in the army and police department, in the entire structure of the constitutional state of Mexico, a systematic and subversive fascistic campaign is being put into operation.

In short the elements of social regression and disturbance of the peace have developed in Mexico gigantically during the two years of our absence, creating right now a situation very similar to that which existed in Spain on the eve of the military insurrection that sacrificed a million and a half of the best Spaniards and threatens Spain with a new feudalism, putting its national independence at risk.

It is urgent, then, for an immediate and energetic call for a reunion of all the country's liberal forces. Only in that way will we be able to push aside the sword of Damocles hanging above our homeland.

In March of 1939, Siqueiros was arrested during a demonstration that became tumultuous when it passed in front of the *Excelsior* newspaper building. Siqueiros telegraphed Cárdenas that his arrest and trial was the first aggressive aspect of the reactionary press's counteroffensive against the antimercenary campaign waged by the organized masses. He said he thought it was useless to refer to the accusations of the press against his having organized the erecting of a stone barrier in a demonstration he had nothing to do with;

in fact, on the contrary, he prevented a continuation of the demonstrators' violence. The Communist party, the Communist Youth, and the Mexican section of the International Red Cross protested Siqueiros's imprisonment.

At the time Siqueiros, in close collaboration with José Renau, applied many of the principles of futurism to the mural of the Mexican Union of Electricians, entitled *Retrato de la Burguesía* (*Portrait of the Bourgeoisie*). Speed, scientific discoveries, premonition, fondness for the visible social realities one must know how to capture, were operative values for him in composing a painting. Like Umberto Bocciono and his friends, Siqueiros was of the opinion that:

> Since we also want to contribute to the necessary renewal of all artistic expression, we resolutely declare war on all those artists and all those institutions which, even disguising themselves with a falsely modern suit of clothes, remain in the tradition, in the academic school and especially in a repugnant mental laziness [...]. Everything moves, everything runs, everything passes by quickly. A figure is never fixed before us; it constantly appears and disappears. By the persistence of the image on the retina, things in motion multiply, change shape, continue as vibrations in the space they travel over. So a running horse does not have four legs; it has twenty, and its movements are triangular [...] The construction of academic paintings is stupidly tra-

ditional. Painters have always shown us things and persons set in front of us. We shall put the viewer in the center of the painting.

These statements made by the futurists in their second *Manifesto* of 1910 are still the main rules of Siqueiros's creative action in 1939. On the other hand, as had occurred with the vanguards appearing before and after the First World War, many active artists after the Second World War tried to appear extravagant and provocative, although their eagerness for originality, an exaggerated concept of themselves, and an excessive subjectivism were only weapons of competition within the artistic fraternity, a fraternity that felt it had to submit to the risks of the open artistic market of the bourgeoisie. Rivalry is constant and is harnessed to the fear of being defeated in the permanent struggle for existence, for success, and for relative power. From romanticism on, artists have wanted to be unmistakable, incomparable; but that desire is the result of a need. Capitalism has freed and continues to free enormous artistic forces. If at the beginning of its development it gave artists new feelings and ideas, now the enormous technical and scientific advances offer them new means of expression. This is why in good measure, starting from the European vanguard, it has been impossible to adhere rigidly to any fixed, slowly evolving style. Science is broadening its scope in a giddier fashion than is artistic invention. As a corrective, proud subjectivity, expressed by any means, brings out feelings noted in the rise

of the bourgeoisie, when art accumulated great critical power, a passionate and contradictory protest against the bourgeois world.

The neodadaist positions are a reflection in art of the contradictions of capitalist society in crisis—this inherited from romanticism; they continue having the character of a petty bourgeois revolt against rules and models, and in favor of including common questions, which usually leads to extreme consequences. No longer are there privileged subjects or materials, nor does the front view or profile of a face give a visible presence of the self. There is no need for an artistic work to be a self-portrait to express the personality of its creator. From the iconological point of view, the self-portrait departs from the raw material that permits the artist to combine formal and symbolic elements and construct the image with a greater subjective charge. In various artistic periods, self-portraits are not very cautious or modest, whereas narcissism is perhaps one of the most enduring qualities and also the most frequent. In creativity the visible part of the self can be the buttocks, as in the self-portrait in the mural that Diego Rivera painted in the California School of Fine Arts in 1931, or the legs submerged in the bathtub of *Lo que ví en el agua* (*What I Saw in the Water*), done by Frida in 1938.

And of all the artist's faces, which is the real one? Juan O'Gorman asked this question, when in 1950 he painted his hand, which in turn painted a rear view of his body seated in front of an easel and wearing a typesetter's eyeshade. On

a cloth hanging on the easel is a three-quarter-view self-portrait, while a mirror on its right reflects the supposedly real image, and on the left he himself as an architect stands holding a plane and carpenter's square, while a small gilded devil sits on his shoulder to give a final touch to the super-faithful face of the model, who is O'Gorman himself. With this notable self-portrait O'Gorman seems to reveal that he opposes the fragmentation of life. In his solitude, the artist has doubts about the diverse accesses offered to this or that specialization. Relentlessly pursued by rationality, he invokes ancestral myths.

When in 1965 André Breton published the revised and corrected version of his book *Le surréalisme et la peinture* (*Surrealism and Painting*), he included as a chapter, without any modification, the article "Frida Kahlo de Rivera," which he had written in 1938 after his trip to Mexico, where he arrived under the auspices of the French Ministry of Foreign Relations to give some lectures at the National University. Diego and Frida had received Breton with great signs of friendship. In those days they were living in Diego's house in San Angel Inn, because the Coyoacán house had been generously given over to Trotsky since 11 January 1937, and he lived there until February 1939, when Rivera's parting of the ways with him obliged him to move to another house, also in Coyoacán, on Vienna Street. Breton and his wife Jacqueline lived for a time in Lupe Marín's apartment and also with Diego and Frida.

Breton's chapter on Frida's painting must have been re-

vised, because it gave extremely warm appreciation to the picturesque and even naturalistic points of view, which do not correspond with the production standards of the best Mexican painters of the times. Breton was unable to see Mexico as sharply as did an Eisenstein or a John Reed or a B. Traven. Breton—the European, the Frenchman—was out of touch with the interests of the emerging world, and died without understanding these phenomena, in spite of the fact that he sometimes signed documents together with Leon Trotsky. How dazzled he was by those *huipiles* (Central American blouses), the *quechquemitl* (Tehantepec blouse), the *huaraches,* the *cambaya* (coarse cotton cloth), the *serape,* the woolen yarn braided in Frida's hair! The pre-Hispanic or popular jewelry—that Frida wore beautifully and with such creative grace—blinded him for a time. Jade and obsidian intoxicated him. So he forgot the content of his first *Manifesto* of 1924, in which he said: "The realistic attitude inspired in positivism, from St. Thomas to Anatole France, strikes me as rather hostile to all intellectual and moral expansion. It horrifies me because it is mediocre, rancorous, and shows poor ability."

Breton saw the apparent, but did not stress the most conspicuous part of Frida Kahlo's personality: the human and artistic indivisibly combined, a constant consequence between dream and wakefulness, wakefulness and dream. A case for the psychoanalyst? Psychoanalysts could find many patients with physical and spiritual problems like Frida's, but maybe very few artists who could sublimate

personal pain in their art, which could well be appreciated without anecdotal references, although in this case the biography in itself may be as fascinating as a work of art.

Frida was a more orthodox surrealist than Breton himself dared to recognize, because she gave her art the quality of a particular harmonic in a secular Mexican context. Rivera pointed this out in the best article he wrote about her. It appeared in the *Boletin del Seminario de Cultura Mexicano* (*Bulletin of the Mexican Seminary of Culture*), Secretariat of Public Education, volume 1, number 2, of October 1943, entitled "Frida Kahlo y el arte mexicano" ("Frida Kahlo and Mexican Art"), p. 89 ff., where he did not dare mention the term *surrealism*. Rivera catalogs Frida's art as "monumental realism," but when he develops this concept, he places Frida's production in the purest surrealist field of action.

Occultist materialism is present in the heart cut in two, blood flowing from tables, bathtubs, plants, flowers, and the arteries closed by the painter's hemostatic forceps [...]. Frida's art is collectively individual, so monumentally realistic that in its total space it is N-dimensional, mathematically speaking. Therefore she paints the exterior, interior, and background of herself and the world at the same time. [...] For Frida the mother figure is the tangible, the center of all, the matrix; sea, storm, nebula, woman. And Frida is the only example in the history of art of someone who tears

her breast and heart open to tell the biological truth about what she feels in them. She painted her mother and her wetnurse, knowing that she really did not know their faces; the nutritive nana's face is only a hard stone Indian mask, and her nipples drip milk like rain fertilizing the earth and tears fertilizing pleasure. Her mother's face is the Mater Dolorosa with the seven daggers of pain making possible the rent through which the baby Frida emerges—the only force which, from the prodigious Aztec master who sculpted the black basalt, molded birth in its own true action. A birth that produced the only woman who has expressed in her work of art the feelings, functions, and aggressive power of woman with insuperable *kalis-teknika*.

In the first *Manifesto* of surrealism, André Breton described the man of his time:

If he still has some brilliance, then he cannot stop looking back to his childhood which, no matter how hard it may have been nor how tormenting for his teachers, he will not consider less appealing. Without restrictions, he is left with many lives lived at the same time [. . .] The judgment of a realistic attitude must be made after the judgment of a materialistic attitude. This last, more poetic than its precedent, certainly implies a monstrous pride on the part of man, but never a new and more complete degradation. Above all, it has

to be seen as a fortunate reaction to certain ridiculous tendencies of spiritualism. Besides, it is not incompatible with a certain loftiness of thought. [...] Thanks to Freud's discoveries, a current of opinions is finally evident enabling human research to advance, authorized at last to bear in mind something more than superficial realities. Perhaps the imagination is on the point of regaining its rights. If the depths of our spirits harbor strange forces strong enough to augment those of the surface, or to fight victoriously against them, then it is right to capture them—capture them first and subdue them later.

And was it not exactly this that Frida Kahlo did by means of her "recurring self-portraits," as Diego Rivera termed them? She sought in the depths of her being the forces she apparently lacked. That she was winning the battle was being shown in the innumerable images of herself, in which her face appears as a different being every time.

Breton said: "Man proposes and disposes. On him depends whether he belongs to himself or is kept in the anarchic state of the daily more fearful handful of his desires." Did not Frida submit to this kind of discipline voluntarily and persistently, without needing the dogma of the *First Manifesto of Surrealism?*

Curiously, for example, no one discusses the condition of the surrealist painter Salvador Dalí, a great exponent of frivolity and whimsicality dedicated to a newly arrived

bourgeoisie; and we still have doubts about the possibility of placing Frida's painting in that current, when her entire self shines with a superlogical reconciliation with everything poetic and loving in the human self. In her paintings and drawings, the naturalistic precision of her face, the plants and animals and ancient ceramics, or the Mexican regional dress is nothing but counterpoint in an overflowing imagination that has broken the limits of conventional reality, and she has not broken them to startle the fools or the bourgeoisie, but for a deep need to take hold of a longer-lasting reality. The fact that Frida may have made herself an almost constant subject in her work makes many people feel that her painting is only a long autobiography. There certainly are a great many autobiographical elements in it, but they never appear with a simple confessional quality, merely as a hyperobjective relationship to something known quite deeply, so much so that it can be submitted to dissection without falling to pieces.

Frida's self-portraits come from a pitiless immersion in the subconscious, perhaps to find the answers that daily life could not give her, filled as it was with the odor of medicines and narcotics. In a detailed catalog of surrealism in the creative arts, her paintings would have to be placed in a most outstanding place in the archives of stern and tragic surrealism, one that for her was like a last resource in a long agony.

During Breton's stay in Mexico, he tried to found an International Federation of Independent Revolutionary Art,

based on a manifesto whose slogan would be "What we
desire is this: independence in art for the revolution, and
revolution for the definitive liberation of art." One para-
graph of that manifesto (a result of long discussions among
Trotsky, Diego Rivera, and Breton) stated that the artist is
naturally allied to the revolution by virtue of the repressions
imposed on him by bourgeois society's lack of harmony, so
that the safeguard of his inner world appears as salvation
for all, as a necessity for emancipation.

In *Le surréalisme et la peinture* (*Surrealism and Painting*) of
1965, besides the article on Frida there is the one Breton
wrote on Tamayo in 1950, and the two on Wolfgang Paalen
in 1938 and 1950. By this last date Breton's aesthetic posi-
tions had changed. In the Tamayo article, and referring to
the art of social behavior, he says:

> The will to subordinate painting to social action is
> shown in Mexico from the beginning of 1920, as the re-
> sult of the initiative of some isolated artists who, how-
> ever, were endowed with some powerful means of
> expression. The strong development of the 1910 Mexi-
> can Revolution offered an ideal sphere of action for the
> glorification of the hopes of the 1917 Revolution in a
> country more violent than any other.

Breton maintains that too much national rootedness led to
decadence, and that Tamayo appears just at the neuralgic
point of the most difficult circumstances to reopen the roads

of great communication that painting, as a universal language, must keep in progress among the continents, and he does this by achieving a basis of unification through diversifying the vocabularies of technical research. That is, not the slightest spark is left from the revolutionary flash, just as no memory of Breton is left on Frida's artistic path.

It could be thought that her recurring portrait was the expression of anguish or frustration, but Frida really came to the subject of her tragedy by making herself the best known, most affectionate, and obsessive subject. Through it or by its medium she stamped on more or less a hundred canvases, nearly all of reduced size, her vital statement, her power, the ultrafine breadth of her imagination. The flesh-and-blood aspect of her painting is like a piece of writing where the tones, the material, the outline of its contents are the terms of an effusive, dignifying, exalting language.

Frida began to paint by herself; but when Rivera returned from Europe in 1928, she began consulting him. The period of his influence was brief, almost insignificant, but together with Diego, Frida was growing and finding herself. He gave her the tools to dig out her own vein. Rivera's prediction came true: Frida Kahlo became one of the best painters in the country. The first to recognize it, to proclaim it, was Rivera himself, and no one knew better than he how to place her work within the creative panorama of Mexico.

When at the beginning of 1953 I met Rivera in Santiago de Chile, where he and the historian José Mancisidor went to represent Mexico at the Continental Congress of Culture,

I asked about Frida. "She is very ill," he replied, almost involuntarily. "She's a great painter. I was amazed when I saw all her canvases gathered into a large exhibit a short while ago. She's a strong, valuable, and profound artist. The only letter Picasso wrote me in his life was about a show of Frida's paintings in Paris. The letter said: 'Neither Derain nor I nor you are able to paint a head like those of Frida Kahlo.'"

To question Diego Rivera about something that interested him meant taking a pencil and paper and writing down textually everything he dictated, including punctuation marks. He expressed himself with such assurance that it would have been sacrilege to change even a single word. While the train ran from Santiago to the south in the crazy Chilean geography, carrying a group of congress members who would visit the University of Concepción, Diego Rivera, admirer of women—who only made friends with women and thought that they would change the future of humanity, adding craftily that man, the male, is an accident, a circumstantial aggregate, a caprice in the evolution of the species—patiently told me his opinion of Frida Kahlo:

Several critics of different countries have found that Frida Kahlo's painting is the most profound and popularly Mexican of present times, and I agree. In Mexico there's a little-known kind of painting that's humble in its physical dimensions and the pretensions of its con-

tent. There are thin layers of metal or wood on which
are painted the miracle with which some saint or virgin
or God favors one or several persons, and these small
pictures are painted to leave evidence in the corre-
sponding sanctuary. Their artists have always been
anonymous, sometimes professionals and at other
times—not a few, of course—the beneficionaries of the
miracles themselves. This kind of painting, ordered by
the poor, earns little money, and the impulse encourag-
ing it to be carried out is entirely pure and free from
pretensions, as much on the part of the artist as of the
people who order the paintings. These *retablos* un-
doubtedly form the most genuine pictorial expression
of the Mexican nation, especially of the peasant major-
ity. All the facets of these people's lives have been
painted because of the miracles.

Among the painters listed as such in the superstruc-
ture of national art, the only one who is closely linked,
without affectation or aesthetic prejudice, to that pure
and popular production—in spite of herself, so to
speak—is Frida Kahlo. The creative characteristics of
absolute sincerity and the completely direct expression
in those *retablos,* among which are many masterworks,
are the same in Frida's paintings. Therefore anyone
who considers her work as most genuinely Mexican is
undoubtedly correct.

On the other hand, it's the first time in the history of
art that a woman has expressed with absolute frank-

ness, unadorned and we could say calmly ferocious, those general and particular events of exclusive concern to a woman. Her sincerity, which we might call both extremely tender and cruel, has led her to give the most unquestionable and certain testimony of certain events. That's why she painted her own birth, her breast-feeding, her growth in the family, and her terrible suffering of all kinds, never exaggerating in the slightest or showing any discrepancy in the precise events, preserving them realistically and profoundly as the Mexican people and their art always do, even in cases when she generalizes events and feelings up to the point of reaching a cosmogonic expression of them. The personal representation of those events and feelings, even the bare bones of their truth, refers to herself, because of her exactitude and intensity, always reaching a universal plane and extension and playing a social role we would dare to call poetically didactic and rigorously dialectic.

Frida Kahlo is really a marvelous human being with a vital force and an ability to stand pain far beyond the normal. As is natural, a higher sensitivity, incredibly pure and susceptible, is united to this power. Corresponding to her nervous disposition, her eyes have an equally exceptional retina. Their microphotography reveals a lack of papillas, which makes Frida's eyes see like the lens of a microscope. Within an infinitely small world she sees much beyond what we see, and this is

combined with a constant power to penetrate the ideas, intentions, and feelings of others. If her eyes are microscopic, her brain has the power of an X-ray machine that makes light-and-dark images of the sensitive intellectual being she observes. This gives her great possibilities of imaginative creation within a reality that is constantly uplifted toward a marvelously fantastic logic in the realm of the unexpected and of the surprise of dialectic connections that are as unsuspected as they are indisputable.

Although her paintings do not extend over the large areas of our murals, by their content in intensity and depth, more than equal to our quantity and quality, Frida Kahlo is the greatest of Mexican painters, and her work ought to be reproduced in quantity. If it doesn't speak from the walls, it will speak to everyone from the books. It is one of the best and greatest creative documents of our times, most intensely real and human, and will be of inestimable value for the world of the future.

Such content cannot help influencing the artist's methods, and cannot help being influenced by the artist's characteristics. Therefore Frida Kahlo is an extraordinarily handsome woman—not with an ordinary and regular beauty, but with the exceptional and characteristic beauty of what she produces. Frida shows her personality in her hairdos, in the way she dresses, in her opulent taste for adorning herself with jewelry that

is stranger and more beautiful than costly. She loves
thousand-year-old jade, and she wears the huipil and
the Tehuantepec costume with skirt of ironed batiste
that the Tehuantepec women and those from Juchitán
in Oaxaca used to wear and still do—those women
who speak Zapotec and Mixtec. Her manner of dress is
the very embodiment of national splendor. She has
never betrayed its spirit, and her national statement has
taken her to New York and to Paris, where the rich
have admired her work and the couturiers have
launched the fashion *Robe Madame Rivera*.

In 1947 with *Tehuana* (oil on masonite, painted in 1943),
Frida took part in the exhibition called "Forty-five Self-
Portraits by Mexican Painters: Seventeenth to Twentieth
Centuries," which the INBA mounted in the Palace of Fine
Arts. For the magnificent catalog designed by the painter
Gabriel Fernández Ledesma, in which every living artist set
forth his or her creed, Frida wrote:

> *I really don't know if my paintings are surrealistic or*
> *not, but I do know that they are the most honest expression*
> *of myself, never taking into consideration the judgments or*
> *prejudices of anyone. I haven't painted much, and that*
> *without the least desire for glory or ambition, with the de-*
> *termination to give myself pleasure and to be able to earn*
> *my living with my work. I've observed everything possible*
> *in my travels—magnificent paintings and very bad ones,*

*too—and I've learned two positive things: to try to the
utmost to always be myself, and the bitter truth that many
lives would not be long enough to paint as I would like,
and all I'd like.*

On 6 November of that same year the National Museum of
Creative Arts was established in the Palace of Fine Arts.
Frida Kahlo figured in the Great Outer Gallery on the fifth
floor, together with Julio Ruelas, Saturnino Herrán, D. Atl,
Goita, Rivera, Montenegro, María Izquierdo, José Clemente
Orozco, Juan O'Gorman, Pablo O'Higgins, Juan Soriano,
and others.

In 1948 the Society for the Encouragement of Creative
Arts was formed; its purpose was "to urge all kinds of
creative arts to unite in search of forms that correspond in
our times to the integral concepts of architects, painters, and
sculptors. These concepts have basically been lost in Europe
ever since the Renaissance, and in America starting from
Spanish colonial days." The Society also proposed

to encourage, in its entirety, the contemporary move-
ment of pictorial, sculptural and architectural produc-
tion along new and present-day forms of expression.
These must correspond to the people's vigorous and
creative capacity manifested in all the ages of ancient
and modern Mexico, always taking into account their
rich creative tradition of barely known forms and con-
cepts, seldom or never utilized and understood. The

Society has the basic objective of contributing to cultural development and to the progress and independence of the Mexican nation.

It committed itself to promote

the general interest of the country's authorities and the public at large, to succeed in establishing solid bases of moral and economic stimulus to permit a greater development of the individual and collective production of Mexican artists. In most cases this comes about in an atmosphere of economic need, without the stimulus relied on by other professionals, whose labor is recognized and paid for by society. We must bear in mind that the artist's work is one of the best contributions to the nation's culture and prestige. We Mexican and foreign painters, architects, sculptors, designers, engravers, cinematographers, and photographers are uniting our individual strengths and experiences to solve common problems, aesthetic as well as economic. All aesthetic or technical points of view—the right to state one's opinions for or against any artistic tendency—are appropriate within the organization.

One of the first activities of the Society for the Encouragement of Creative Arts was to organize a collective show, in which Frida participated together with Rosa Castillo, Federico Canessi, José L. Ruiz, Francisco Zúñiga, Miguel

Prieto, Luis Arenal, Olga Costa, Angelina Beloff, Fernando Castro Pacheco, Jesús Guerrero Galván, Juan O'Gorman, José Chávez Morado, José García Narezo, Raúl Anguiano and José Gutiérrez.

In 1949 Frida took part in the inaugural show of the Hall of Mexican Creative Art with her painting *El abrazo de amor entre el Universo, la Tierra, yo y Diego (The Love Embrace of the Universe, the Earth, Diego and Me)*. In the same year, the National Institute of Fine Arts honored Rivera for his fifty years of artistic labor with a large exposition in the Palace of Fine Arts, for which a great book-length catalog was printed. Approached by the organizers, Susana and Fernando Gamboa, Frida wrote a "Portrait of Diego," which Diego praised with amazement and joy:

I warn you; I'll paint this portrait of Diego with colors I do not have—words—and so it will be a poor account. Besides, I love Diego in such a way that I cannot be a "spectator" in his life, but a part of it, so perhaps I will exaggerate the positive in his unique personality, trying to push out of sight what could even remotely hurt him. This will not be a biographical report; I consider it more honest to write solely about the Diego I think I have known a little in these twenty years I've lived near him. I will not refer to Diego as my "husband," because that would be ridiculous. Diego has not been, nor will he ever be, anyone's "husband." Or as a lover, because he contains much beyond the sexual limitations; and if I were to speak of him

*as a son, I would only be describing or picturing my own
emotions, almost my self-portrait, not Diego's. With this
warning and with all clarity, I will try, within my ability,
to tell the only truth—my own—that sketches his image.*

HIS PHYSICAL APPEARANCE: *With an Asiatic
head on which grows dark hair so thin and fine that it
seems to float in the air, Diego is an overgrown child with
a pleasant face and a slightly sad look. His dark, bulging,
large, and very intelligent eyes, set much farther apart than
any others, find it hard to stop moving, almost out of their
orbits, with their swollen and bulging lids like a frog's.
They're used to taking in a much broader field of vision, as
if they were especially made for a painter of spaces and
crowds. Between those eyes—so distant from each other—
one can divine the invisible part of Oriental knowledge,
and very seldom does an ironic and tender smile, the flower
of his image, disappear from his Buddha-like mouth with
its fleshy lips.*

*When seeing him naked, one thinks immediately of a
childish frog standing on its hind legs. His skin is greenish-
white like that of some aquatic animal; only his hands and
face are darker, from the sun.*

*His narrow and rounded childlike shoulders continue
without angles down feminine arms ending in marvelous
hands, small and finely drawn, and as sensitive and subtle
as antennas communicating with the entire universe. It is*

*amazing that those hands have been able to paint so much
and can still work without tiring.*

*It has been said of his chest that if he had disembarked
on Sappho's island, he might not have been executed by her
warrior women; the sensitivity of his marvelous breasts
could have made him admissible. Although his specific and
strange virility also makes him desirable in the lands of em-
presses avid for masculine love.*

*His enormous belly, spherelike smooth and tender, rests
on strong legs, handsome as columns and ending in big feet
turned outward at an obtuse angle, as if to take in the en-
tire earth, and be invincibly supported on it like some ante-
diluvian being from which might emerge, from the waist
upward, an example of future humanity, distant from us by
two or three thousand years.*

*He sleeps in a fetal position and when awake moves in a
slowly elegant way, as if living in liquid. In the sensitivity
he shows when moving, the air seems thicker than water.*

*Diego is shaped like a deeply affectionate monster whom
the grandmother, Ancient Concealer, —necessary and eter-
nal matter, mother of men and of all the gods they invented
in their delirium out of fear and hunger,* WOMAN, MYSELF
*among them all—had always wanted to hold in her arms
like a newborn baby.*

HIS CONTENT: *Diego is on the margin of all precise
and limited personal relationships. Contradictory, like all*

that sets life in motion, he is at the same time immense af-
fection and a violent discharge of powerful and unique
forces. He lives within himself like a seed the earth trea-
sures, and outwardly like landscapes. Some people probably
expect me to paint a very personal, "feminine," anecdotal,
entertaining portrait of Diego, filled with complaints and
even a certain amount of gossip—those "decent" bits of
gossip able to be interpreted and used according to the sick-
liness of the readers. Perhaps they may expect to hear com-
plaints from me about "how much I'm suffering" by living
with a man like Diego. But I do not believe that the banks
of a river suffer by letting it flow, nor that the earth suffers
because it rains, nor that an atom suffers when it discharges
its energy . . . For me, everything has a natural pervasive-
ness. Within my dark and difficult role by being allied to
an extraordinary human being, I have the recompense of a
green point in a sea of red: a recompense of balance. *The*
joys or sorrows normal to the life of this society in which I
live, rotten with lies, are not mine. If I have prejudices and
other people's actions hurt me, even Diego Rivera's, I take
responsibility for my inability to see clearly. And if I have
no prejudices, I must admit that it is natural for the red
cells to fight the white ones without the slightest bias, and
that this phenomenon means nothing but health.

I will not be the one to devalue the fantastic personality
of Diego, whom I deeply respect, by saying stupid things
about his life. On the other hand I might want to express,

with the poetry I lack, what Diego really is—as he de-
serves.

He already speaks prodigiously about his painting, his
own painting.

The scientists will take charge of his function as a hu-
man organism and of his valued cooperation in social revo-
lutionary work, of his personal and objective labors, all
those who know how to measure his incalculable transcen-
dence in time; but I, who have seen him live for twenty
years, have no means of organizing and describing the liv-
ing images which might portray—even if feebly, but
deeply—the most basic aspects of his figure. Only a few
opinions will come out of my dullness, and they will be the
only ones I can offer.

The deep roots, the outer influences, and the real causes
shaping Diego's unequaled personality, are so vast and
complex that my observations are probably small buds on
the many branches of the gigantic tree that is Diego.

There are three main directions or lines I consider basic
in his portrait: the first, that of being a constant revolution-
ary fighter—dynamic, extraordinarily sensitive and vital;
an untiring worker at his trade, which he knows like few
painters in the world; a fantastic enthusiast for life, and at
the same time constantly discontent for not having suc-
ceeded in knowing more, building more, and painting
more. The second, that of being eternally curious, a tireless
researcher of everything. And the third, his absolute lack of

prejudices and therefore of faith, because Diego, like Montaigne, accepts that "when doubt ends, stupidity begins," and the one who has faith in something admits unconditional submission, without the freedom to analyze or to vary the course of events. By this extremely clear concept of reality, Diego is a rebel, and with his marvelous knowledge of the materialistic dialectic of life, Diego is a revolutionary. From this triangle, over and above what the rest of Diego's nature fashions, comes a kind of atmosphere that envelops the whole. This mobile atmosphere is love, but love as a general structure, as movement is a builder of beauty. I imagine that the world he would like to live in would be a great fiesta, in which each and every one of its beings would take part, from men to stones, from suns to darkness—all cooperating with their own beauty and creative power. A fiesta of form, color, movement, sound, intelligence, knowledge, and emotion; a spherical, intelligent, and loving fiesta to cover the entire surface of the earth. For that fiesta to take place, he struggles continuously and offers all he has: his genius, his imagination, his words, and his actions. At every instant he fights to abolish man's fear and stupidity.

Diego is continually attacked for his intense desire to help change the society in which he lives into a more beautiful, healthier, less sad, and more intelligent one, and to put all his creative power, his constructive genius, his penetrating sensitivity, and his constant labor at the service of that positive and inevitable social revolution. During these

*twenty years, I have seen him struggle against the ultra-
complex interlocking of the negative forces opposed to his
push for liberty and change. He lives in a hostile world be-
cause the enemy is the majority, but this does not make
him a coward, and as long as he lives new enterprises, ve-
hement, courageous, and intense combats, will always leave
his hands, his lips, and his entire being.*

*Like Diego, all who have brought enlightenment to the
world have struggled; like them, Diego has no "friends,"
only allies. Those who emerge from themselves are magnif-
icent because of their brilliant intelligence, their clear and
profound knowledge of the human material they work in,
their solid experience, their great culture not derived from
books but inductive and deductive, their genius and desire
to build, with the mortar of reality, a world free from cow-
ardice and lies. In the society in which he lives, all of us
who, like him, realize the imperative need to destroy the
false bases of the present world—all of us are his allies.*

*Diego always reacts firmly, and with a great sense of
humor, to the cowardly actions against him. He never
compromises or backs down, and confronts his enemies
openly—most of them crafty and some of them
courageous—always counting on reality, never on "illu-
sions" or "ideals." In Diego this intransigence and rebellion
are fundamental; they complete his portrait.*

*Among the many things said about Diego, these are the
most common: he is called a mythomaniac, a publicity
seeker, and—the most ridiculous—a millionaire. His de-*

sire for exaggeration is directly related to his tremendous imagination, that is, he lies as much as do poets or children to those who still have not considered their schools or mamás stupid. I have heard him tell all kinds of lies, from the most innocent to the most complicated stories about important people whom his imagination puts together in fantastic situations and behaviors, always with great humor and a marvelous critical sense, but I have never heard him tell a single banal or stupid lie. Fibbing, or playing at it, unmasks many people, reveals the inner mechanism of others, who are far more ingenious liars than he; and the most curious thing about Diego's supposed lies is that sooner or later those involved in the imaginary combination are annoyed, not by the lie but by the truth contained in the lie, a truth that always rises to the surface. It is then that "the henhouse becomes excited" because those annoyed are discovered in a place where they thought they were the safest. What really happens is that Diego is one of the very few who dare attack at the base, face to face and fearlessly, the structure of the hypocritical society we live in—called MORAL—*and since the truth does not offend, but troubles the people whose shaky and best-hidden secrets are discovered, they can only call Diego a fibber or at least an exaggerator.*

They say he seeks publicity. I would say that others try to do it with him to some extent, for their own interests, but they do it with badly applied Jesuit methods, because they are generally "failures." Diego does not need any pub-

licity, much less what is given to him in his own country.
His work speaks for itself. Not only for what he has done
in Mexico, where he has been shamelessly insulted more
than anywhere else, but in every civilized country in the
world—countries where he is recognized as one of the
most important and brilliant men in the field of culture. It
is certainly incredible that the meanest, most cowardly and
stupid insults against Diego have been vomited in his own
house: Mexico. From the press and some barbarous acts of
vandalism by those who have tried to destroy his work,
from the innocent parasols of "decent" ladies who scratch
his paintings hypocritically and as if in passing, all the way
to acids and table knives. [Here Frida refers specifically to
the crime of 4 June 1948, the object of which was to de-
stroy the mural Dream of a Sunday Afternoon on the
Alameda, *at the Hotel del Prado, when hundreds of stu-*
dents from the Engineering School, using a kitchen knife
from the hotel, scratched out the words "does not exist"
from the phrase, "God does not exist," pronounced by the
miracle worker of the Letrán Academy.] And let us not for-
get the usual spitting, worthy of the owners of as much sa-
liva as few brains. And the signs on the walls of streets,
with words not proper for such a Catholic people. And the
groups of "well-educated" young people throwing stones at
his house and his studio, destroying irreplaceable works of
pre-Hispanic Mexican art that form part of Diego's
collection—the persons who "have a good time" and then
start running away. And the anonymous letters—it is use-

less to talk about the worth of their excuses—and the neu-
tral, Pilate-like silence of the powerful, charged with
caring for, or imparting culture to, the country for its good
name, but not giving any importance to such attacks
against the work of a man who, with all his genius, his
unique and creative effort, tries to protect freedom of ex-
pression not only for himself but for everyone.

All these night-and-day maneuvers are made in the
name of democracy, morality, and Long Live Mexico! And
sometimes also Long Live Christ the King! All this pub-
licity that Diego does not seek and does not need proves
two things: that his work, his entire work, his unquestioned
personality, are so important that they must be taken into
account by those whose hypocrisy and newly rich, shame-
less plans he throws in their faces, and by the weak and de-
plorable state of a semicolonial country that permits the
occurrence in 1949 of things which could only occur at the
height of the Middle Ages, in the times of the Inquisition,
or while Hitler was top man in the world.

To recognize Diego—marvelous painter, brave fighter,
and complete revolutionary—they wait for his death. As
long as he lives there will be many "machos"—those edu-
cated in pigpens—who will continue stoning his house, in-
sulting him anonymously or in his own country's press and
in other still more macho countries, and who will wash
their hands and pass into history wrapped in the banner of
prudence.

And they call him a millionaire ... the only truth in this

matter of Diego's millions is that, being an artesan and not a proletarian, he owns his tools of production, that is to say, of work, the house he lives in, the rags he throws on himself, the rickety pickup he uses the way tailors use their scissors. His treasure is a collection of marvelous sculptures, jewels of indigenous art, living heart of the true Mexico, which with ineffable economic sacrifice were collected over more than thirty years to place in a museum in process of construction for the past seven years. He has built this work by his own creative efforts and with his own economic endeavors, that is, with his marvelous talent and the earnings from his paintings. He will donate this collection to his country, leaving to Mexico the most prodigious source of beauty that has ever existed, a gift for the eyes of the Mexicans who have eyes, and incalculable admiration from those abroad. Except for this, economically he has nothing; nothing except his power for work. Last year he did not have enough money to pay the hospital after an attack of pneumonia. Still convalescing, he began painting to be able to meet daily living expenses and pay the salaries of the workers cooperating with him, as in the Renaissance guilds, to build the marvelous work in the Pedregal.

But attacks and insults do not change Diego; they form part of the social phenomena of a world in decadence, that is all. On the contrary, life as a whole continues to interest and amaze him, but nothing disappoints or daunts him, because he knows the dialectic mechanism of phenomena and events.

An ultrakeen observer, he has achieved an experience which, together with his knowledge—I would say of the inner meaning of things—and his intense culture, permits him to penetrate causes. Like a surgeon, he cuts open in order to see, to discover the deepest and best hidden, and attain something certain and positive that improves the circumstances and functioning of living things. That is why Diego is neither a defeatist nor sad. He is basically an investigator, a builder, and above all an architect. He is an architect in his painting, in his way of thinking, and in a passionate desire to build a harmonious, functional, and solid society. He always composes with precise mathematical elements, no matter if his composition is a painting, a house, or an argument. His foundations are always reality. The poetry in his work is the poetry of numbers, the living sources of history. His laws, the firm and physical laws that rule life in the totality of his murals, live with the very construction of the building containing them, and with their organized practical functioning.

The stupendous structure, called El Anahuacalli *(the house of Anahuac) being built in San Pablo Tepetlapa, destined to guard his unequaled collection of ancient Mexican culture, is a blending of the old and new, a magnificent creation to revive and preserve Mexico's incomparable architecture. It is being built in incredibly beautiful Pedregal like an enormous cactus overlooking Ajusco, sober and elegant, strong and delicate, ancient and perennial. It shouts with the voices of centuries and days from its volcanic stone*

entrails: Mexico is alive! Like Coatlicue, it contains life and death; like the magnificent terrain from which it rises, it embraces the land with the tenacity of a living and permanent plant.

Always working, Diego does not live a life that could be called normal. His capacity for energy breaks clocks and calendars. Materially speaking, he lacks the time to fight without rest, because he is constantly projecting and carrying out his work. He generates and accumulates waves difficult to compare with any others, and the result of his receptive and creative mechanism, though being so vast and immense, never satisfies him. Images and ideas flow in his brain with a different rhythm than the ordinary, and that is why his intense fixation and his desire always to outdo himself are uncontainable. This mechanism makes him indecisive, but his indecision is superficial, because in the long run he succeeds in doing what he pleases with a sure and well-planned will. Nothing describes this part of his character better than a story his Aunt Cesarita, his mother's sister, once told me. She remembers that when Diego was very young, he went into a store—one of those big, rickety, mestizo shops that carry everything and are full of surprises and magic—the kind we all remember affectionately. Standing in front of a showcase with a few cents in his hand, he looked again and again at everything in the world the store contained, while shouting desperately and furiously: "What do I want?" The store was called "El Porvenir" ("The Future"), and this indecision has lasted all

of Diego's life. But though he seldom decides to choose, he carries within him a vector that goes directly to the heart of his will.

Being eternally curious, he is at the same time an eternal talker. He can paint for hours and days without rest, chatting while he works. He discusses everything, absolutely everything, enjoying it with all who want to hear him, like Walt Whitman. His conversation is always interesting, astonishing, and at times wounding; some of his sentences are moving, but he never leaves his audience with the impression of uselessness or emptiness. His words make a person feel tremendously uneasy, because they are persuasive and true. The crudity of his concepts unnerves his hearers or robs them of control, because none of those concepts come together with the established norms of conduct; they always break open the bark to let new leaves sprout; they wound in order to let new cells grow. To some people—the strongest—Diego's conversation and truth seem monstrous, sadistic, and cruel; to others—the weakest—he is frustrating and annihilating, and as a defense these persons call him a liar and preposterous. But they all try to defend themselves very much like people who shy away from the vaccine the first time in their lives they are confronted with a vaccination. They appeal to hope or something that will free them from the danger of truth, but Diego is all out of faith, hope, and charity. He is extraordinarily intelligent by nature, and he does not admit the possibility of ghosts. Stubborn in his opinions, he never

gives in, and he defrauds all who shield themselves in belief or false kindness. So they call him immoral, and he really has nothing to do with people who accept the laws or norms of morality.

In the midst of the storms that clocks and calendars are for him, he tries to do, and stops doing, what he considers just in life: working and creating. He is belligerent in all other directions, in other words he never scorns the value of others but defends his own, because he knows this means a rhythm and relationship in proportion to the world of reality. He gives pleasure in exchange for pleasure, effort in exchange for effort. Having more ability than the rest, he gives a much greater quantity and quality of sensitivity, asking only for understanding. Often he does not even get this, but that is not why he neither surrenders nor gives in. Many of the conflicts his superior personality causes in daily life stem from that natural lack of control provoked by his revolutionary concepts in relation to those already submitted to rigidity and rules. The household problems that several of us women have had while near Diego consist of the same thing. Diego has a deep class consciousness and awareness of the role other social classes play in the general running of the world. Of the persons who have lived near him, some of us want to be allied to the cause he works and fights for, and others not. So a series of conflicts is started, in which he is embroiled, but he is not responsible for them, because his position is clear and easily seen. His unprejudiced and humane sense of unity—whether

due to genius, education, or change—is not responsible for other people's inability, or for the consequences this brings to social life. He works for all forces to organize and progress in greater harmony.

What weapons can a person use to fight for or against a human being who is closer to reality, more within the truth, if these weapons are moral, that is to say standardized according to the expedience of a specific person or human sector? They have to be amoral and rebellious, naturally, to what is already established or admitted to be good. I—with the fullness of my responsibility—do not think I can be against Diego, but if I am not one of his better female allies, I would like to be. Many things can be deduced from my attitude in this portrait essay, depending on who deduces them; but my truth, the only one I can tell about Diego, is here. Clearly stated and not measurable in sincere-meters, which do not exist, but convinced of what concerns myself, my own existence.

No words can describe Diego's immense tenderness for beauty, his affection for human beings who have nothing to do with present-day class society, his respect for those oppressed by it. He especially adores the Indians to whom he links his blood; he loves them deeply for their elegance, their beauty, and because they are the living flower of America's cultural tradition. He loves children, all animals, with special affection for the Mexican hairless dogs, and for birds and plants and stones. He loves all humans without being docile or neutral. He is very affectionate, but never

surrenders, and because he scarcely has the time for per-
sonal relationships, he is called an ingrate. Diego is respect-
ful and courteous, but nothing makes him more violent
than the abuse and lack of respect for others. He cannot
bear clever deception or sneaky deceit, that which in Mex-
ico is called "pulling your leg." He prefers intelligent en-
emies to stupid friends. By temperament he is rather light-
hearted, but it irritates him enormously to have time taken
from his work, because his diversion is work itself; he hates
social gatherings, but the really popular fiestas amaze him.
At times he is timid, and just as it fascinates him to con-
verse and discuss things with everyone, sometimes he is en-
chanted by being absolutely alone. He is never bored,
because everything interests him: studying, analyzing, and
digging deeply into all of life's manifestations. Sentimen-
tality is not one of his qualities, but he is intensely emo-
tional and passionate. Inertia drives him mad, because he is
continually moving in a lively and powerful way. With ex-
traordinary good taste he admires and appreciates every-
thing beautiful, whether it vibrates in a woman or a
mountain. Perfectly balanced in all his emotions, sensa-
tions, and actions—those moved by precise and real mate-
rialistic dialectics—he never gives in. The way a cactus
grows from the earth, he grows strong and astonishing, in
sand as well as in stone, flowering like the brightest red,
the most transparent white, and the sunniest yellow; cov-
ered with thorns, he takes shelter in his tenderness; he lives
with his powerful sap in a ferocious medium. In a solitary

way he sheds light like an avenging sun on the gray of a
stone; his roots stay alive in spite of being pulled up from
the ground, rising above the anguish of solitude, and sad-
ness, and all the weaknesses that humble other people. He
bounces back with surprising energy and gives flowers and
fruit like no other plant.

This loving text, written with the most spiritual generosity, makes useless the many discussions and interpretations concerning the numerous reasons that united Frida and Diego.

Frida's only one-woman show in Mexico while she was alive opened on 13 April 1953 in the gallery of the photographer Lola Alvarez Bravo. The invitations she sent out contained some rhymes in the popular style composed by Frida herself, handwritten by her and printed on three small sheets of heavy paper tied with red cord:

With friendship and affection
coming straight from the heart,
it gives me pleasure to invite you
to this exposition of my art.

At eight o'clock at night,
that's what the clock hands say,
be at Lola Alvarez Bravo's place
and I hope you won't say nay.

The address is Amberes number twelve,
the door is on the street.

Though particulars are lacking,
just simply follow your feet.

I only want you to give me
your opinion sincere and fine;
you pose as being learned,
so let your knowledge shine.

These canvases I've painted
I did with my own hands;
they wait for you upon the walls
to please you as I planned.

That is enough, my dearest pal.
with friendship deep and true,
Frida Kahlo de Rivera
sends heartfelt thanks to you.

Five

Her House, Her Things

Anyone entering Frida Kahlo's bedroom for the first time would feel extremely sad. It was a place where her illness had made her spend a great part of her life, where cardboard and paper Judases, all decorated with brilliant contrasting colors—to be set on fire with the deafening noise of rockets on Holy Saturdays—adorned her bed like a canopy. The big Judas, more like a burlesque skeleton, was attached to a mirror placed all along the canopy's top. In the daytime the mirror constantly reflected Frida's sleeping or waking image.

On the bedroom walls were many photos of admired personages or well-loved people, and stamped in red letters

by the heavy hand of Manolo, Rivera's helper and servant in Coyoacán, were the names of her principal women friends and lovers: Elena Vásquez Gómez, Teresa Proenza, María Felix... Several wardrobes and shelves held small pre-Hispanic sculptures, some of which were taken after her death to the Anahuacalli of San Pablo Tepetlapa, the stone museum Rivera built in the Pedregal hills for keeping his collection of pre-Hispanic pieces.

On the serape-covered twin bed slept Xólotl, the Mexican hairless of pure American breed who once urinated on the watercolors that Master Diego had just painted. Furious, Rivera chased the dog all around the house, waving a huge machete and primed for a kill. When he caught up with him, arm raised to give him a quick blow, the silent little animal sighed instead of barking, and wagged his short, thin tail violently, as if repentant. That inarticulate plea for clemency found an echo. Putting the machete under his arm, Rivera picked up the dog and sensuously caressed his smoke-colored, coal-colored, volcanic-stone-colored hide, saying to him: "Lord Xólotl, Emperor of Xibalba, Lord of the Darkness, you're the best art critic there is." Frida laughed as she recalled the episode, and her laughter was reflected in the wardrobe mirror, in the ceramic puppies, in the multicolored glass balls, in the many and various shining objects so characteristic of popular Mexican decoration, and in the glass panes of the curio cabinets that guarded her jade and alabaster marvels. Frida's short and jovial outbursts of laughter, so strident, echoed in the branches of a

tree that grew in a corner of the room, and very gently moved the garland of medicinal plants hanging from seven flowerpots sitting on the upper part of the window, dying green the light that the stone walls softened in both heat and cold. Green also was the glass-topped box holding the tiny lace dress in which Diego María de la Concepción Juan Nepomuceno Estanislao de la Rivera Sforza Barrientos D'Acosta y Rodríguez de Valpuesta was baptized. On the yellowish cloth lay Diego's first dolls, little girl Frida's favorite dolly, and a small pair of high shoes like the ones she wore after her polio attack. Scattered among her candid mementos were figures of reptiles and frogs, among which stood out the rock crystal frog, symbol of "the childish frog standing on its hind legs," as Frida physically pictured the man with whom she had had a beautiful but unusual relationship for twenty-five years.

Once I had begun to frequent that room without equal in all the world, the oppression of the first moment, caused by the odor of medicines and narcotics and the sounds of ampules and syringes, changed into a most affectionate sense of its being a toy store. Melancholy, physical pain, and the scars on Frida's body were caused by the accident, but her bedroom was no accident; it was orderly. The order she put there showed her hopes and feelings; it indicated that the one who imposed it found comfort in that grotesque candidness, was affected by the innocent workmanship, and revered the objects arising from her habit of collecting beautiful things.

Before the Conquest, Coyoacán was a town on the shores of Lake Texcoco; in the early years of the century it was one of the more peaceful wooded settlements in the metropolitan zone. The conquistador Hernán Cortés sought refuge there for several months, after having totally destroyed the ancient Tenochtitlán. The last great Mexican lord Cuauhtemoc was tortured by the Spaniards there. His small hamlet was built near Ajusco, whose high mountains block the horizon. Far from the town's main square, on the corner of Allende and Londres streets, was built the low but spacious blue-walled house where Frida was born on 6 July 1907. After her death in 1954, the house was made into a museum dedicated to her person and her work. It had been built in 1904, when Wilhelm Kahlo acquired the land at the time when the large El Carmen hacienda, belonging to the Carmelites, was split into small lots. The hard-working photographer wanted to live far from the city's center and had decided to live with his family in Tlalpán, but his wife, Matilde Calderón y González, convinced him to go to Coyoacán.

The house was rectangular, with a garden and fruit trees in the patio, and this was borne out by the oil painted by Frida toward 1936: *Mis abuelos, mis padres y yo* (*My Grandparents, My Parents and I*), also entitled *Arbol genealógico* (*Genealogical Tree*). Another unfinished version of this is in the museum, and in it appear Frida's sisters, María Luisa and Margarita, daughters of her father's first marriage, and Cristina, the youngest, together with Matilde and Adriana,

the two eldest. We can also see the sketched-in figures of the
nephew and niece (Isolde and Antonio Pinedo Kahlo) and
the brother who had died at birth, phantoms she took a
sudden notion to interpret as the not-yet-born children she
always painfully hoped for.

When Diego married Frida, he went to live in that house,
although he always kept his studio in the house Juan O'Gor-
man built for him in San Angel Inn, where Frida lived
when Trotsky settled in Coyoacán. When Diego moved
back, after the tense and finally tragic Trotsky episode,
toward 1940 Rivera built a wing on the house, an addition
that faced Londres Street. Long before this he had built a
stepped pyramid in the center of the patio to contain the
choice pieces of what would become one of the most notable
collections of ancient art in the world: 55,481 objects. On the
top floor of the new wing were his studio, bedroom, and
Frida's private quarters.

The rooms Rivera built make a chapter in Mexican
architecture; in them he achieved a charming blend of
regional accents and a certain sobriety that was recognized
as being functional. The walls are a dark gray volcanic stone
from Pedregal, warm and full of pain at the same time.
High up on the walls he installed clay pots, in which the
pigeons did not take long to find shelter. On a small breeze-
way to the right on the old wing, he affixed enormous snails
and a green mirror, details of an ornamental grace that was
strong enough to bear the imposing weight of the stone. To
stress and separate the character of the new, Rivera built a

wall in two parts to divide the large patio shaded by tall trees: the smaller portion for the stone house and in the center a fountain with a jet of water falling from a tangle of seaweed and snails. Rare birds in cages rocked stridently from the high boughs of the tallest tree; at night their swaying in the darkened garden sounded like the fabulous laments keeping alive the legend that Trotsky's tormented ghost has been ambling through the halls—a wide-spread myth among the people of Coyoacán for some time.

At Diego's request, Frida went to Tampico to wait for Trotsky and his wife Natalia on the ninth of January 1937. The Bolshevik leader moved into the Coyoacán house on the eleventh. Frida's charming personality had an impact on him, and there was a sufficiently intense mutual coquetry between them to arouse Natalia's jealousy, but this attempt at flirtation was not the reason for Diego and Frida's divorce in 1940. The reasons, impossible to document, must be found in the role played by Rivera in the first and second attempts on Trotsky's life, Siqueiros's failure, and Trotsky's execution by Ramón Mercader, whose sister was painted by Rivera.

In the largest part of the garden was the stepped pyramid, a reflecting pool, and a small room standing alone and containing some select archeological pieces, a room that Rivera, perhaps to startle people, called the "Temple of Tláloc," god of rain and lightning, one of the oldest objects of adoration among the people of Mexico and Central America.

Little by little, as if they had grown out of the stones, pre-Hispanic figures and vessels were taking their places there, and along with them some sculptures by Mardoño Magaña, the janitor at the Open Air School of Painting in Coyoacán; Rivera admired him as one of the most talented present-day sculptors. On the plain ceiling of the vestibule he installed a handsome mosaic of natural stones, recognized by Juan O'Gorman as an important antecedent for the murals Rivera painted with that technique on the walls of the Central University's austere library tower. Everything in the house was Mexican with a spark of art—*retablos,* modeled or decorated sweets, reed grass and glued paper, Judases, toys from a fair, profusely decorated furniture made of pine and fir; skeletons made of plaster, tin, cardboard, sugar, and China paper that the people use to scare off gloomy thoughts on the Day of the Dead; paper cutouts; peasant dresses embroidered with an infinite variety of fretwork; floral birds and designs; cushions on which both sentimental and picaresque expressions had been embroidered with threads of all colors; candelabras, thuribles, fans, small boxes, trunks, anonymous paintings, sleeping mats, serapes, sandals, paper and wax flowers, headdresses, wooden rattles, piñatas, masks... everything was finding its place, acquiring the grace of necessary objects, never the heaviness of useless decoration. The familiarity of one next to the other gave them an unexpected power. There the past and present were joined with emphatic naturalness. Diego and Frida were arrangers of a montage of historic transcen-

dence that had a determining influence on a certain sector of Mexican intellectuals. As the years went by the whole house—both the new and the old wing—acquired the color and flavor of its inhabitants' spirit. In her diary, Frida wrote inside of a drawing: "A house of birds, a nest for love, and all for nothing."

Among the popular artesans and artists whose work is found in Frida's museum, there is a woman who makes her presence felt because of the objects she creates: the judas maker Carmen Caballero Sevilla. Her impressive work has always been sold at such a low price that no one has ever thought of writing an article about her. Once in the patio of Rivera's studio in San Angel Inn, Doña Carmen told me some details of her artistic development:

> I was eighteen when I began studying with a man
> called Gregorio Piedrasanta. We lived on Melchor
> Ocampo Street. I became a fruit seller. My father was a
> lieutenant colonel in the Revolution and died when I
> was five. My mother made a business of selling fruit,
> and I went along with her doing the same thing. One
> day Gregorio Piedrasanta offered to teach me, and
> that's when I made my first judas. To learn even more,
> I stayed with him for about a year and was very well
> taught. When I finished making judases, I branched
> out to making butterflies and cross pieces for oil lamps.
> These are made out of tin and cork, and the butterflies
> out of cards and candlewicks with some paraffin wax.

Then he taught me to make masks, and the last thing
he taught me was to make a crude skeleton marked
only with stripes, not an open-work one, and I made
other skeletons with my talent, and this led me to mak-
ing the heads of monstrous idols.

Doña Carmen used various methods in her art:

Cast judases: A carpenter makes the form out of *patol* or
colorín (a shade tree). To do this he cuts down a branch
and makes the form with a knife. You can also make a
form out of plaster or stone, and it takes a day or less.
When the form is done, you cover it with paper from
cement bags, coat it with a paste made of flour and wa-
ter so it sticks, hollow it out and then plug it up. When
that's done you let it dry, and when it's all dry you
paint it a Spanish white, and after that you can use any
colors you like.

Reed funeral carts: The reed is cut into long, narrow
strips. When that's done we make little wheels and the
basket, and after that we cover it—we call that "dress-
ing it". We cover it with plaster, paint it white, and
pick out a color anyone wants for the final coat. The
aniline dye is stabilized with a gelatiny paste and it can
be rose-colored, green, yellow, blue, Spanish blue, royal
blue, green ochre, red ochre, lime green, purple ... We
also mix colors to make different shades.

Openwork funeral carts: We split the reeds and make the

little wheels, attaching them to make the basket. Then it's covered with paper and painted the way I said, and decorated with aluminum white or aluminum gold dissolved in ichthammol or thinner.

Wire skeletons: We start off by making the jawbone and then the head. Then we make something like small springs for the eyes and begin weaving pieces of wire together in a sort of embroidery, using tweezers. These little skeletons don't move, except for their jaws. We cover them with paper.

Doña Carmen's relationship with Rivera:

I met the *patrón* in the Abelardo Rodríguez market while selling judases. One Holy Week I went to that market with lots of judases and I saw the *patrón* there; he painted a picture of me with all my judases. Then I delivered a 2.5-meter judas to him made out of 150 reeds. It was my first delivery to him with some other small skeletons, and so he asked me if I wanted to be his special judas maker and I said yes. So he invited me to his house, bringing half a dozen skeletons. I delivered them, and that's where I met Señorita Frida. Then he kept buying my work. The *patrón* won't let us take our work to the plaza, doesn't want it to get wet, because then people would make fun of it. After that I began working for the *patrón* every year, and when I had a little more time, I kept working for him on all

kinds of things he asked for: small skeletons of thin copper and wickerwork, dressed-up judases, ones with giant-sized heads, and quick-stepping judases showing their feet. The only judases in the *patrón*'s studio that aren't ours are the ones with the big noses. Before Jorge Negrete died, the *patrón* asked me if I could make an image of María Félix or Gloria Marín for him, but I couldn't. Then he asked us to make one of him, and we made him a huge one he paid us 200 pesos for. I didn't only get established from that, but Señorita Frida ordered Christmas Eve toys from me: piñatas, maguey, different kinds of little houses. I make all kinds of toys: Christchilds, ducklings, baby lambs, all kinds of Christmas decorations. I make piñatas in the shapes of lyres, clowns, Cantínflases, cowboys, radishes, roses, artichokes, watermelon slices, bulls. Young Frida was the one who accepted me most; she paid me a little more than the *patrón* did. She didn't like to see me without any teeth. Once my man beat me so hard I lost my teeth, so then when I made something very pretty she gave me these gold teeth I have now. I'm grateful to her. I delivered a skeleton to her by myself and she put clothes on it and even a hat.

Rivera's relationship with Doña Carmen:

In 1951 I ran across her and her man selling judases in the Abelardo Rodríguez market. At first we thought

he was the one who made them, until they started
fighting. The man took away the money, beat her, and
smoked marijuana. Then it was the son who took the
money away from her. Carmen Caballero is a genuine
declaration, an enormously talented artist, a typical case
of what goes on in Mexico. The true art of Mexico is
called "popular"; it is created by villagers for the peo-
ple, without any additions or sophistication, and it goes
far beyond what the school and gallery painters at-
tempt. If a well-known painter had done what Doña
Carmen did, everyone including the critics would have
sung halleluiahs. The proof is that Henry Moore, while
waiting for me, made some sketches of the skeletons
hanging in the Coyoacán house, sketches of which
Mathias Goeritz had copies made as Moore's murals on
a wall of *El Eco* in 1953. The hoax was certainly
Goeritz's fault, not Moore's, and proves that all of Car-
men's work is what the sophisticated artists would like
to do, but don't succeed in doing. Anyone who sees
these creations of Doña Carmen's has to realize that the
really astonishing thing—apart from the feeling caused
by her sensitivity to form and color—is that of treating
each example, one and the same subject—a skeleton, a
death figure—absolutely differently, and the difference
is not forced or affected, but vital. Doña Carmen's tal-
ent lies in that aspect like the genius of Picasso, an art-
ist who painted dozens of guitars and bowls of fruit or
violins, each expressed in a very different form and

content. So we may conclude that Doña Carmen's
work is within what the aesthetes call great art. If it
weren't for class prejudice, I would have to give her a
higher mark than is given to 99 percent of the academy
graduates and gallery exhibitors. Doña Carmen's things
have the very same distinctive characteristics as pre-
Hispanic American art. I've always repeated, and shall
never tire of doing so, that the rest of the world's art
lies within the classic and the romantic, given the abil-
ity to determine the creative conditions of both desig-
nations. The classic is the movement of form, which
some people translate by outlines, drawing, rhythm,
etc. Delfos's *Auriga* (*Coachman*), Sicilia's *Escriba sentado*
(*Seated Scribe*), and *Apollo;* the works of Rafael,
Leonardo, Giotto, Ingres, etc. We can determine that
romanticism is form in motion. In cases of exceptional
genius, both qualities in an artist are combined. Three
basic examples of this would be Brueghel, Mathias
Grunewald, and, above all, the immense Francisco de
Goya y Lucientes. Among the great romantics, or those
who can manage form in motion, we must put the
Byzantines, who made the mosaics of the Early Em-
pire, and Tintoretto and Greco. This last artist carried
the exaltation of this quality as far as to deserve what
they say about him, which is that he painted the move-
ment of sensations, emotions, and light. Titian and
Velázquez must be placed completely within the classic
examples, in spite of the fact that Velázquez produced

a type of optical phenomena, or form in motion, in *Las hilanderas* (*The Spinners*). The great French masters of the nineteenth century, Daumier, Courbet, Cezanne, Renoir, and Seurat are also cases of romantic classicism. Pre-Columbian art, on the other hand, has a different quality. Without losing the possibility of expressing movement in form and form in movement, this art reached a unique quality not found in the ancient world except in the marvelous works of art inscribed on or cut into rocks, and in the modern world in the works of Van Gogh's greatest period of exaltation. This last is the expression of form in motion, an occurrence in which size, color, line, and the course of the composition are modified, in order to reach the vital justice of expression that impels the artist by means of these modifications, constituting—if it can be said—a higher realism, since energy or movement lies at the root of existence itself. Therefore expressing the form of this last has to be considered as the highest realistic expression.

This is what exists in Doña Carmen's work, as it exists when Picasso expresses the depths of his very self by producing a masterwork. This happened with Van Gogh, but it always occurs in masterworks made by artists such as Doña Carmen, for they are the contemporary expressions of much more than twenty centuries of creative culture, and they are born of, and live with, naturalness like a shell, a flower, an animal in motion,

or an extraordinary human being, but within the present social structure they are only given scant praise. The great sycophants of the arts and of criticism talk of those works as *Mexican curios,* displaying with utmost clarity the dullness of their sensitivity, the falseness of their criteria, and the terror that a popular work, selling for almost nothing, is not only a threat to them, but to all the vested interests of their speculators—vile rubbish and hostile to the art of the people. They are reluctant to give it a higher rank than that of "curiosities" for tourist consumption, because if they admitted what was really there, they would have no clients, and their own production would have no purchasers but garbagemen. All these circumstances, which are doubtless evidenced in the people's clearest secret perception, have surely produced the enormous and formidable ironic power of Carmen's works. Looking at the whole of these *calacas* [death figures], we can find all facets of the human animal in Carmen's life, everything treated with an overflow of fantasy. Doña Carmen's little skeletons, as objects, have a place in the typically Mexican toyshop, but the spirit of her creations have a precursor she may possibly be unaware of: José Guadalupe Posada. Nobody like those two have been able to relieve the human skeleton of all tragic sense and metaphysical effort by changing it into a pure element of corrosive grace, more literary in Posada, more sensory in Doña Carmen. In both, all the mov-

able bones are like an unfleshed being where life is expressed more intensely.

When Doña Carmen was about sixty, she lived on the Puebla highway, where the dust clouds flew furiously and enveloped the house-cave-hovel she lived in, a place that was her home, workshop, kitchen, and grief. Misery had worn her down, as had the unfortunate life that had given her her man: Santos Miranda. Out of the twenty children born to her, only four lived, and out of the thousands of judases that have left her hands, not one of them with its brilliant colors adorned her wretched bedroom made of rusted sheet metal and layers of cardboard or paper glued with paste. A judas maker's judas room filled with unpainted judases—like saying naked judases to be dressed for Holy Week.

After Diego and Frida were dead and the Coyoacán and Anahuacalli museums were built, the judases they had ordered from Doña Carmen were preserved, and it was she who restored those that were still restorable.

Among the photos of saints and of Pedro Infante, the place of honor in the hovel was that of a magazine cover with a color photo of her patrón Diego, whom she remembered with emotion because he had supported her, admired her, ordered her work, and felt the immense sympathy deserved by such a prodigious talent. Carmen Caballero had no economic sense, no ability for adding or subtracting, no possibility of saving up anything except a few tears that

ran down her old lady's dusty ashen face when she recalled
that she had been defrauded when she wanted to purchase a
plot and build a little mausoleum on it to receive the bodies
of her "patrones."

In February of 1969 Carmen Caballero told me:

> At least he might have left me a remembrance for
> my work; he didn't leave me anything, but I'm not
> dead and I can still be of use to them. Many people
> think I'm crazy, but these hands know how to make a
> pretty cardboard skeleton. It's all over, my lungs are
> going bit by bit, and in spite of having been very sick
> and not working for a very long time, the boys of San
> Carlos Academy come here to look for clowns and
> masks for their dances, and they go off with big heads
> for Carnival. I made some skeletons for an Academy
> girl who painted a mural of all tiny skeletons. The
> other day the millionaire Don Antonio also came and
> carried away six clowns for a show in a school. The
> painter and sculptor Jorge Gonzales Camarena wants
> me to work with him on a concrete mold, but Holy
> Week is coming, and after Holy Week I have to make
> magueys, little pine trees, piñatas . . .

In July of 1959—five years after Frida's death—the house
where Frida was born and died opened as a museum named
after her. Those of us who had been in it before, who had
known the real usefulness of her things, approached afraid

of encountering some cold arrangement of them, but we received the enormous surprise of seeing that unique intimacy, without having betrayed the original, transformed into one of the most beautiful museums in Mexico City. Of course not everything could remain as it was before. The irremediable absence of the inhabitants compelled substituting their daily environment with a supradomestic one. The poet Carlos Pellicer, a sporadic museum specialist, solved the problem with his extremely keen intelligence. Things remained almost where they had been, but instead of keeping the order of those who had lived in the house, they acquired an order from the visitor's point of view. The wooden doors of the wardrobe were changed for glass. The paintings no longer leaned in corners of the studio, but were hung on the walls in an orderly way. Frida's intimate letters and papers were removed from the desk, unfolded and placed in showcases, where the visitor could read them at leisure. Rather than have Frida's projects piled up in boxes and baskets, they were spread out to reveal the conflicts of their creator. There were no dinner leavings on the table, and the pots and pans in the big kitchen were as shiny as if on display in a department store. The extreme disorder of daily living solidified into a definitive order, where the truth was altered only as much as was necessary to stress certain meanings.

In the halls dedicated to Frida's work, some of the paintings—the few finished or unfinished ones which were there when she died—could be evaluated. In the rooms put aside

for Rivera's work, the visitor could not fail to remember the museum in Orozco's house in Guadalajara, where one could also discover, in an almost imponderable manner, the creator's conflicts. The Rivera section had no important paintings, scarcely a few sketches of youthful creative experiments, but they were important material for the studious.

Diego and Frida's rooms had remained almost the same as they were in the last years of their lives. The visitor could recognize that the person in charge of arranging everything had a standard for respecting the sensitivity of the two extraordinary artists who had lived there. Of course many things had to stay in the drawers. All had been distributed in a plausibly sober way. But Pellicer, through forgetfulness, committed a serious and unjustifiable error on opening day: he forgot to include, on those walls where everything important had found a place, some photo taken by Guillermo Kahlo, to whom Frida owed her first stammerings in art. Next to Joaquín Clausell's landscapes, next to one of Orozco's lithographs and some flowers by José María Velasco, he should have placed, but did not, a small group of photos by that artist who undoubtedly deserves a place of honor in his specialty, and even more so in the house he built with no idea that it would ever become a fine museum of Mexican art—the art he admired and served with exemplary humility. In the photography archives of the National Institute of Anthropology and History, and in the vaults of the National School of Creative Arts in the National University, there are extremely valuable collections of Guillermo's photos, a body

of work which today, in spite of the technical progress in this field, can be considered unsurpassed, thanks to his analytical penetration and to the vast area it comprises. It is his work that illustrates the monumental six volume treatise: *Las iglesias de México* (*The Churches of Mexico*), carried out around 1924 by Dr. Atl in collaboration with the critic Manuel Toussaint and the engineer Benítez.

As the years went by, the Frida Kahlo Museum failed to receive from the Bank of Mexico Trust enough attention to preserve its contents and even add more. The growth of Frida's international prestige and the value of her work did not find an equivalent response from the museum's custodians.

Six

Teacher of the Young

In 1942 the School of Wood Carving of the Secretariat of Public Education became the School of Painting and Sculpture. It held its classes in an old building at 14 Esmeralda Street. This little street was almost an alley, and the school building a single room and a patio, both very large, where the studios had been distributed as well as possible. The groups of the different specialties mixed in a kind of primitive freedom that could cure all inhibitions at once. The school tried to renovate the teaching of art, according to its administrator, Antonio M. Ruiz, who said: "This school's slogan is based on the present spirit of national reconstruction, and for that very reason it is, and must be, work and

study, indispensable factors for spurring on a spiritual resurgence in Mexican arts."

The faculty consisted of a group of outstanding figures in the creative movement of the Mexico of those times: Diego Rivera, Manuel Rodríguez Lozano, Germán Cueto, María Izquierdo, Jesús Guerrero Galván, Federico Cantú, Carlos Dublán, Francisco Zúñiga, Feliciano Peña, Fidencio Castillo, Luis Ortiz Monasterio, Carlos Orozco Romero, Agustín Lazo, Rómulo Rozo, Frida Kahlo, José L. Ruiz, and Enrique Azaad, and included the surrealist poet Benjamín Peret. To encourage enrollment the classes and materials were free, and the system at La Esmeralda (the students didn't take long in giving this unencumbered name to the place) was characterized by a total lack of rigidity. The relationship between student and teacher was flexible, and the school sought to develop the students' initiative to the utmost—an experimental and somewhat anarchical system, from which individuals who were aware of their abilities could profit. The ones lucky enough to have Frida as a teacher received far more than a didactic orientation; they were given a way of living, of being, and of thinking that was much different from the usual, such as concern for the national and social order, a vision of solidarity with the Mexican people, and in addition, a delicious sense of humor, coarse and refined at the same time.

When Frida started giving classes at La Esmeralda, she had already begun to develop a rare and very special temperament—strong, expansive, and penetrating, enthusiastic

and truthful. She could decorate the truth, invent it, tear it to pieces, but she never used subterfuges. She was credulous, believed in people, in their word, their history, and their dreams. She was jealous—jealous of their property, passions, hatreds, and also of all their singular qualities. Humility and resignation were not part of her character, and at Rivera's instigation, she had come to make a cult of herself for friends and relatives. If there was vanity, caprice, and even a certain insolence in that attitude, she never fell into foolishness or arrogance; it was a point of support for her rebelliousness in the face of misfortune. Rivera's influence on her pictorial creativity was circumstantial and basically nonexistent.

When she took charge of the faculty of the beginning painting courses at La Esmeralda, Frida Kahlo went through a brilliant period of creativity. After a formidable series of self-portraits—*Tehuana (The Tehuantepec Woman)*, *Diego en mi pensamiento (Diego in My Thoughts)*, *Pensando en la muerte (Thinking of Death)*—there followed the tense portraits of three women of the Morillo Safa family (the mother, Lupita, and Mariana); then some symbols, at once bitter and vigorous—*La columna rota (The Broken Column)*, *A mí no me queda ya la menor esperanza ... todo se mueve al compás de lo que encierra la panza (I No Longer Have the Least Hope ... Everything Moves to the Rhythm of What the Belly Holds)*; miniatures with a magic sense of display— *Diego y yo (Diego and I)*, of which there are two versions; still lifes with anthropomorphic allusions—*La novia que se*

espanta al ver la vida abierta (*The Bride Astonished at Seeing an Open Life*); some Freudian-occult compositions—*Moisés* (*Moses*); and sarcastic drawings—*El surrealismo es la mágica sorpresa de encontrar un león dentro del armario donde se estaba seguro de encontrar camisas* (*Surrealism Is the Magic Surprise of Meeting a Lion in a Wardrobe Where You Were Certain You Would Find Shirts*). All this and more between 1943 and 1945.

Believing that she could overcome her endless ailments, Frida started the course for her large group of students in the school's inhospitable location; they had signed up with her because of her fame, or her rich and unusual Tehuantepec dresses that swept the floor with their starched lace frills, or for the strange jewelry she adorned herself with so lavishly. The tyrannical demands of a torn body made her return to the confinement from which she had tried to escape. But being with the young people brought her a joy she did not want to give up, so she kept on teaching and managed to have the classes continue in her home. The administration of the school now backed the plan by underwriting the cost of the trips the students had to make to out-of-the-way Coyoacán every day from Monday to Friday. The blue house in Coyoacán, with its octopus and shell, made a marvelous classroom for the painting courses Frida Kahlo could not teach in that poor studio at La Esmeralda.

The group that began the trips to Coyoacán was made up of quite a number of students, but dropouts reduced the number to four: three young boys and a girl, all fanatically

enthusiastic about the teaching methods of that unique teacher. They were Fanny Rabel, Arturo García Bustos, Guillermo Monroy, and Arturo Estrada, a fraternal group their friends nicknamed "Los Fridos."

In the patio or in the large studio on the first floor, the four young people painted whatever they wished; the classes were serious but completely informal, and if some discipline was needed in this environment, it was an inner and self-imposed one. Frida was not a teacher in the academic sense; she was an initiator and talked equally to her students about impasto or balance as about the ideological currents of our time or the political value of folklore. With the same tenacity and empathy, she pointed out the baseness in the line of reasoning that falsely interpreted the tragic episodes of the war that in those days was tearing apart Europe and the world. With equal stubbornness she made them memorize the words of a ballad of the 1910 revolution Lenin wrote about art and the masses: "Art belongs to the people. It must sink its deepest roots into the great toiling masses. It must be understood and esteemed by those masses. It must join the feelings, thoughts, and desires of those masses, raise them to a higher level, and rouse and develop artists among them."

After Frida's death Rivera would write: "Frida shaped students who today figure among the most valued men and women artists of Mexico. She always encouraged them to preserve and develop their personalities in their work and in the social and political clarification of their ideas." This

Rivera wrote at the request of the National Institute of Fine Arts, on the occasion of a show of Mexican painting in Lima, Peru.

Rivera not only did not collaborate with Frida in the teaching of art, but he did not even approach her to see what her students were doing. His studio was in the neighboring San Angel district, nearby but far enough away to avoid the tensions caused by continual communication between two such hypersensitive temperaments. "Los Fridos" would see him at a distance on the rare occasions when he lived in Coyoacán, from which he usually left very early in the morning to return very late at night.

In spite of his physical absence, Rivera was a model of perfection for the novices' aspirations. And who was Rivera? He was the most methodical, the most industrious, the best informed, the most professional, and the best read of Mexican painters. A precocious talent with a most unusual thirst for knowledge, he had been systematically kindling, with a lucid and scientific tenacity, the various stages that took him to a prodigious mastery of his technique and intentions. A fanatic in things artistic, he had sold his soul to painting (the Balzac of colors), up to the point of draining himself and becoming disconsolate, alienated, overburdened with other people and things, and surfeited with civilization. His painting—eminently explosive, didactic, and spirited—left nothing to chance; he had no confidence in the imagination of the viewer or in his own; he re-examined everything, told everything; we have to know

where we are and where we came from, to know where we are going. If he described an object, he did so in its most definitive details; if he tackled a situation, he made those involved in it concur in its resolution; if he defamed some circumstance in his images, he would immediately correct it by praising its opposite. A vigilant and rationalistic rigidity that only permitted itself the levity of some pleasant jokes and the poetic or sentimental license of a voluptuous pantheism. In the power of that ultrasensitive and phenomenally prolific painter, in the thousands of square feet of fresco painting he produced without rest, Mexico was gradually gaining its true face.

For his great and logically structured compositions, Rivera utilized classicism and its latest derivation, cubism; to express his pantheistic optimism, he made use of impressionism and its extreme result, fauvism; to relate history, he resorted to naturalism and to its most flexible period, folklorism; to give time and movement to his images, he utilized romanticism and its retrospective example, archeology. So it can be said that Rivera was a new breed of academic artist, sufficiently advanced to use known formulas in creating a new kind of art, Mexican in character and content, universal in meaning.

"Los Fridos" certainly did not receive a coherent explanation of that gigantic personality; nobody thought up for them a method for systematically approaching his creative genius; but in the kind of living together that Frida Kahlo as their teacher had encouraged them to undertake, they

were tacitly assimilating the aesthetic principles that would anchor them to Rivera's realism for a long time.

While most of La Esmeralda's teachers urged the students to quickly end their pictorial exercises, Frida Kahlo let them find their own rhythm of production. But every week at the beginning, and later every two weeks or every month, she instigated a lengthy collective criticism that tended to develop, earlier than others did, a sense of self-criticism, which should have harmoniously been joined by a sense of solidarity with the indigent classes, fortified by the fundamentals of Marxism. The imperative was unique and inevitable: painters must be useful to society, fighters who ought to win a place by their work in the first ranks of the vanguard; their painting ought to be a weapon in the class struggle. This was often an unattainable ideal, even for Frida herself, who had confessed to me: "My painting is not revolutionary, so why do I keep pretending it's combative? I can't." The awareness of this ineptitude kept her from ever presenting her own paintings as an example; she merely offered, to those who might understand, the magical key to her palette that she consigned to her diary, in among meditative or nightmarish illustrations:

> *Green:* a good, warm light.
> *Reddish purple:* Tlapalli Aztec. Old prickly-pear blood.
> The oldest and brightest.
> *Brown:* color of chile sauce (*mole*) or fading leaves.
> Earth.

Yellow: madness, sickness, fear. Part of the sun and of
joy.

Cobalt blue: electricity and purity. Love.

Black: nothing is black, really nothing.

Leaf green: leaves, sadness, science. All of Germany is
this color.

Greenish yellow: more madness and mystery. All
phantoms wear suits of this color . . . or at least
underwear.

Dark green: the color of bad news and good business.

Navy blue: distance. Tenderness can also be this blue.

Magenta: blood? Well, who knows?

At the end of 1944, the teachers of La Esmeralda showed a
sample of their students' work in the Palace of Fine Arts. It
was the first exhibition of importance held by the school,
and its success so far surpassed predictions that many of the
eighty-four beginning painters and sculptors ("Los Fridos"
included) were sure of being in the right vocation. Since
"Los Fridos" were recognized as a homogeneous group, the
School of Painting and Sculpture sponsored a show of their
work in a small hall of creative arts on Palma Street, open-
ing on 1 February 1945.

An admirer of landscapism and the so-called popular
Mexican painting of the nineteenth century, Frida induced
her students to perfect themselves in mastering the most
complicated details; it was also important that the scope of
their work be broad, with perfect drawing of architectural

elements and trees, a document of fidelity in the most insignificant complementary elements. The works shown in the first sample of "Los Fridos" art responded to this tendency. It might be thought that in 1945, when photography and documentary films were fully developed, an artistic preoccupation of this kind was not only anachronistic but retrogressive—a judgment supported by the entire formalistic preaching of contemporary aesthetics, which tended to consider art's past as oppression, from which it was necessary to free oneself in order to achieve discovery of the new. What must be understood is that the first efforts of "Los Fridos" were not directed to the new; the subject of their anxiety was the simplicity and clarity of past artists— the simplicity and clarity they would also need in order to exalt things of the common people. Stimulated by their teacher, they hoped that the common people would identify with their paintings. They believed that this identification could help foster an awareness of appropriate values in the country's most abandoned masses. Besides, they realized that they had to recover some forgotten or unpopular forms to thoroughly enrich contemporary Mexican art. They were sure that by following those footsteps, they would gain their own artistic culture and an original creative method.

The time came when "Los Fridos" understood that they needed a broader range of experience than that offered by their teacher. They wanted to share the artistic problems and tasks with their generation. So they joined forces with other students and became the Union of Young Revolution-

ary Artists. The group's first activities consisted of popular shows in parks, markets, and working-class neighborhoods. Since this was an unusual cultural activity in the city, it did not take long to attract powerfully the attention of many different public sectors, even more so when instead of the usual picturesque aspect of this kind of show, the young artists had been careful to give it some social importance and, especially, on the part of "Los Fridos," a solid political value. The places the young painters preferred were Coyoacán, Tacubaya, the Alameda, Atzcapotzalco, the Chapultepec Woods, and the garden of Santa María la Rivera. They set up their improvised galleries on market days: in Coyoacán on Fridays, in Tacubaya on Saturdays, in Chapultepec on Sundays.

To celebrate the thirty-fifth anniversary of the 1910 revolution, the Young Artists organized on 20 November the Free Art Exhibition in the Alameda gardens. For that festivity three of "Los Fridos"—Estrada, Bustos and Monroy—painted a canvas as a team; its title was *Quiénes nos explotan y cómo nos explotan (Those Who Exploit us and How They Exploit Us)*, based on a dialectic plan of the forces oppressing the Mexican people. The enormous crowds visiting the open-air show had absolutely no complaints about the painting, neither as a work of art nor as an expression of political thought. But what the work represented made some anonymous hands hurl a good deal of sulfuric acid at it, which damaged the painting. There was a movement of protest, and the young painters, supported by numerous

renowned artists, charged that the authorities lacked the vigilance and protection needed for those young painters' creations. They demanded compensation, some rules to cover such a situation, and that the Department of Creative Arts of the Secretariat of Public Education establish a precedent with its position. It all ended when a fortuitous purchaser carried off the painting by paying nine hundred pesos for it.

It is certain that the scandal arose because the painting's message left no room for doubt: behind an altar with the revered image of the Virgin of Guadalupe appeared the archbishop, who was contritely praying while his faun's ears pricked up to receive advice from the ambassador of imperialism who, arm in arm with the capitalist and striking the politician, whispered his plans, counting on the support of the unscrupulous military man whose one hand threateningly clutched a dagger while the other was stretched out to receive the coins offered by the frightened politician. The group was supported by factories and churches, from which emerged the mass of subjugated workers and peasants, dying of hunger, who came to deposit their pittance in an immense money box at the foot of the altar, on whose pedestal appeared the eye of the Most Holy, observing the fainting bodies of the victims of misery.

According to Rivera, in a statement to the press (*Tiempo,* 7 December 1945):

It is unquestionably a work of creative qualities, a bal-

anced composition of expressive form and harmonious
color, and an exact picture of the social state of Mexico
in 1945. It shows the underclass lying on rubbish heaps,
dying of hunger, filth and misery; undernourished, im-
poverished laborers made stupid by a religious neurosis,
wandering among the factories where they are ex-
ploited, and in the city made filthy by such colonialism,
where they lodge their illiteracy, leaving (in the center
of the composition) much of the little they earn to
maintain the glory of a substitute for the old idols.
Above all this the exploiters—archbishop, imperialist
banker, warlord, whose sole purpose is to be against the
people—and the demagogue who disguises the actions
of the other exploiters. The people did not react against
the painting, because they felt the truth of their situa-
tion when it was so clearly depicted; the acid, thrown
precisely at the face of the demagogue, surely came
from some inhabitant of a pseudocultural institution,
no matter what its initials. The acid, the purchase, etc.
succeeded in having the painting removed from the
show before its time, which is precisely what all the
Guadalupe worshipers and sons of San Francisco
wanted to achieve.

To strengthen their position after the crime, the group
published on 11 January 1946 a statement addressed to "the
people of Mexico," revealing the socialist euphoria prevail-
ing in the most advanced and active sector of cultural life.

We younger painters, sculptors, writers and en-
gravers of Mexico have formed a group whose purposes
are the following:

In the first place, to put our artistic production in di-
rect contact with our people, which we shall do by
means of outdoor traveling shows in plazas, markets,
gardens, and other places.

Secondly, to use art, which is our medium of expres-
sion, to fight all those bandits and exploiters who tram-
ple on the people in a thousand ways, making them
live a wretched and inhuman life and blocking the way
to their liberty and progress.

Thirdly, we, the younger artists of Mexico, stand be-
side the great and true revolutionaries to continue
struggling for social, economic, and political progress in
Mexico; that is to say, we shall struggle with complete
determination for Mexican life to be better and better.

The first classes in monumental composition, just like the
first decorative classes taught by Frida Kahlo, were very far
from any scholastic orthodoxy. In a burst of humor, perhaps
wanting to break the oppressive quiet of Coyoacán, even
fleetingly, she found a good excuse in digging up something
forgotten: *pulquería* (saloon) painting. Frida surely had no
wish to restore any tradition; she only wanted to amuse
herself in her own way, and to do that she once again
substituted for academic solemnity, which bored her horri-
bly, a Dionysian and playful kind of display that would have

as its pretext the outer walls of La Rosita pulquería, situated near the Coyoacán home of the dethroned King Carol of Romania.

For Rivera and his closest student, the architect Juan O'Gorman, pulquería painting was a genuine artistic creation of the people, thanks to whose practice the fresco tradition had taken root in Mexico. In an exalted way, Rivera and his followers opposed the Mexican bourgeoisie's taste for the shoddy and excessively sentimental, capricious pranks, and the ironic force of the murals with which some anonymous painters had decorated the walls of the pulque sellers—those places where Mexicans dream, curse, recall old times, chat, confess, scream, die, or start to live. But they considered that forbidding the painting of those walls was a triumph of the Europeanized deformers of the national character. Juan O'Gorman was a person who maintained that the most backward of Mexicans never gave up their aesthetic pleasure, because it was at least as vital to them as any other; that if the decorations disappeared from the walls, the pulque would have a different flavor for the customers; that if the walls simply returned to being dividing partitions, the catalyst would be missing that could prevent their expansion.

For his part, José Clemente Orozco, whose first muralistic scrawls justly had a place on the walls of a bar, congratulated himself that social changes had done away with that and other expressions he considered suitable for a backward and debased people.

The movement to reappraise pulquería painting had strengthened. In an effort to reestablish the decorations, Juan O'Gorman painted the walls of five pulquerías between 1926 and 1927. It is certain that the forced decadence of the pulquerías marks the beginning of Mexico's industrial climb. Maybe for that reason Orozco, so fond of radical progress, left the most emphatic negative views, in his *Autobiography,* written at the request of the newspaper *Excelsior:*

> Between 1924 and 1926 the fabulous story of pulquería painting appeared; it was the sublime expression of the Mexican people's creative genius, a powerful and immortal creation of a cosmic race, earthly convulsive, a copy of ancestral cosmogonies and a breath of the gods, etc. [. . .] All the poor pulquería paintings have disappeared without a trace, not exactly because of earthly convulsions, but for having been painted with paste and glue. A few days ago I still saw a pulquería, called Los tigres ("The Tigers"), in the San Rafael district, and it was only because of the name that we guessed that the paintings were of tigers. They looked more like mangy dogs without the slightest grace or originality. It is useless to search the city for any other paintings in the Mexican people's pulquerías. Not a one is left.

Frida used La Rosita's walls to practice the kind of mural

painting stipulated by the school's official program; only her fantasy made her surround that practice with a pleasant reconstruction of bygone times in a proud blend of modern pedagogy and communitarian compromise. The students, whose number in that unusual class increased inopportunely from four to sixteen, presented projects very much adapted to traditional pulquería painting. Two compositions they selected for subject and style joined the iconography that characterized the output of the Open Air Schools: an idyllic representation of peasant scenes complemented by decorative elements of plant forms. This last seemed to be a derivation of Adolfo Best Maugard's teachings. Rivera gave the beginning muralists some technical orientations, and Frida encouraged them to persist in a minutely precise and beautifully finished kind of painting that praised the peasant family in its labors and domestic habits.

The unveiling of La Rosita's murals can be considered as the most purely surrealistic action that may have occurred in Mexico. On the appointed day, from very early in the morning in the plazas, markets, and streets of Coyoacán, flyers were distributed that said: "Today, Saturday 19 June 1942, at 11 A.M., a grandiose debut of the decorative paintings of the great La Rosita pulquería will take place." It was sponsored by the painter Antonio M. Ruiz, principal of La Esmeralda. There were rockets, fire crackers, balloons, confetti, fireworks, a mariachi band, a parade of important people marching from Frida's house to the pulquería; a delicious barbecue was served, sprinkled with the finest pulque

brought especially from the most prestigious ranches. At the
height of the celebration, the student Guillermo Monroy
sang the ballad he had written especially for the occasion:

> To paint our La Rosita
> has cost us lots of work.
> The people have forgotten
> the pulquería art.
> Doña Frida de Rivera,
> the teacher we so love,
> says: Come, you girls and boys,
> and I shall show you life.
>
> Our friends of Coyoacán,
> if you desire happiness
> La Rosita waits for you.
> Just look at all its beauty!
>
> I do not want to get drunk,
> look cross-eyed or see double;
> I only want some happiness;
> that's what the poor desire!

The most beautiful popular and revolutionary songs were
sung all through the day, and Frida Kahlo, surrounded in
the middle of the street by students, friends, and neighbors,
was not the "nocturnal sphinx," but gaiety in spite of every-
thing.

Painted in oils on the outer walls of La Rosita without

much care, the paintings lasted in all kinds of weather far longer than was predicted. But in 1952 Frida considered that the moment had come to renovate them, so she went to Rivera's helpers working on the monumental relief of the University City stadium; among them were two of "Los Fridos," Arturo García Bustos and Arturo Estrada. The oil technique was changed to fresco, and as the repainting was done to celebrate Diego Rivera's sixty-sixth birthday, it was decided to represent the most commented-upon sentimental events of the moment, events which to a certain extent aroused Frida's jealousy. It was she who chose the actress María Félix, the poet Guadalupe Amor and her own husband as the central figures in the composition called *Amamos la paz y el mundo de cabeza por la belleza (We Madly Love Peace and the World for Their Beauty)*, in which she herself had a leading role.

The second exhumation of pulquería painting by a group under Frida's orders served to activate a shared sense of humor—a complex and at times black humor, but always one with satiric inventiveness and a shade of melancholy.

The unveiling of the second version of the La Rosita murals was as sensational or even more so than the first. The journalist Rosa Castro, who participated in this celebration, years later called forth the "woof" feelings as opposed to the "weft" ones. In the paper *El Día,* in her "Gallery of the World" column of 19 July 1966, Rosa wrote:

Frida spoke of her ills as if referring to a retort with

a strange animal inside that resists the fire over and
over again. Those corsets she wore—oh! made of
metal, leather, plaster, and with which she amused her-
self by painting them with gentian violet and mer-
curochrome, and that she embellished with little
mirrors of dancers glued with colored feathers in the
pubic region. Those corsets of Frida Kahlo that had to
be put on by hanging her from a heavy cable sus-
pended from a rafter in a room of her house. Those
corsets that tortured her so fiercely—how well I re-
member them! And how well I remember that eve-
ning; night had fallen when she decided to take one of
them off. 'Never again,' she said, and without the cor-
set, without the support for her fragile backbone, she
went out into the street and to a hotel to celebrate the
opening of a painting show of hers in a pulquería near
her Coyoacán home.

I was waiting for her at the house along with a thou-
sand people—a thousand? Maybe more. They came in
great numbers from everywhere; they were in the gar-
dens, among the archeological objects, in the pyramid,
under the immense bougainvillea on the terrace, in the
rooms of Colima skulls, in the room of *retablos* and in
her own room, which seemed to me to be dazzling,
spectral, and grotesque that day. From the rafters on
the ceiling hung a multitude of large judases, half a
meter apart and all dressed in Frida and Diego's

clothes; cardboard and paper legs swung in continuous motion from below the pants and full skirts, moved by whoever passed by. And there was her bed, waiting for her, with its four dark bedposts holding up a kind of mirrored canopy.

An uproar in the street took us to the door, the great front door at the entryway. How to describe the impressive spectacle that matched her dazzling room? Right in front came Frida, her hair down, tottering, excited, her arms up in the air. Following her a shouting, singing, laughing, and whistling crowd. In the dust they raised and in the darkness increasing by the minute, it seemed like a crazy and exorbitant rebellion of human beings invented by Frida herself. She made it to the front door with difficulty, but she was shouting: 'Never again! Never again, no matter what happens! Never again!'

What enormous spiritual discipline enabled her to overcome her own situation, her solid reality, the reasonable limits of her physical condition and state of mind. In a burst of talent she mixed muralism and folklore in a masquerade that had a tremendous load of suggestions. A pure state of surrealism without diligent research, without intellectual cost. That was a surrealist "action" in which painting, properly stated, occupied a secondary place. If many of Frida's paintings endure for their exceptional quality, the mural

Amamos la paz y la tierra de cabeza por la belleza had the slight rank that corresponded to the game, to the throw of the dice that Mallarmé was so enthusiastic about.

After the first mural exercise—a very instructive action for those who knew how to balance the values brought into play—Instructor Kahlo consigned to "Los Fridos" the walls of some public laundries built by the efforts of a group of extremely humble washerwomen in the middle of some vacant lots in Coyoacán, facilities they named Casa de la mujer Josefa Ortiz de Domínguez; the name was later changed to Casa de la mujer Ana María Hernández.

The subject developed by "Los Fridos" on three of the laundry walls was the lives and emotions of the women who went to do their washing there every day: unmarried mothers or widows, abandoned women, wives who had to respond to all the needs of a household torn apart by vice, orphaned and deserted girls. To raise them out of their bitter social condition, "Los Fridos" attached themselves to a socialist-realist aesthetic: cause and effect, a statement of motives and message. 'To overcome your present condition, whose objective causes we show clearly and graphically before your eyes,' they seemed to be saying with the paintings, 'you must fight with your whole consciousness, together with your equals, by taking as examples the illustrious women of your homeland's history, so that you will accelerate the changes in the society you live in. Your dignity depends on your will, and you must be optimistic, because if you have gained anything up to now, thanks to

your sense of human solidarity, you will gain much more in the future, thanks to following a political program.'

Due to the publicity obtained by the La Rosita paintings in 1944, Frida received a commission to decorate the wedding banquet halls in the Posada del Sol hotel. Since the physical effort demanded by the mural painting was impossible for her, she succeeded in having Saldana Galván, the hotel's owner and a friend of hers, pass on the commission to the students. While those frescos were being painted, school days ended for "Los Fridos." In La Esmeralda some of the artists received the pompous title "Artist-painter—Worker in the Creative Arts," which was of almost no use whatsoever. The "Los Fridos" group dissolved. Frida Kahlo's teaching had reached its end. But the effect not only persisted, it deepened as the painters matured. A good proof of this is the portrait of the dead Frida that Arturo Estrada showed in his first one-man exhibit in the Salon of Mexican Painting in June of 1955. The introduction written by Diego Rivera for the catalogue is filled with the most intense grief. He plays with words, speculates on Frida's death, and is nostalgic about the absence of that woman whom he had never dared paint without life.

> Arturo's tragedy is ours; it is unconditional tragedy in full splendor, the radiant color of marvelous and naive flowers, because the most submissive, amiable, and witty of our women friends is Lady Death, elegant or ragged and uncultured, and ever since childhood we've

been chewing on sugar skulls, and when we become adults we're in the habit of watching over the dead with match heads. And when our tragedy occurs—the deepest and most irreparably atrocious tragedy—we receive it with marvelous floral decorations, accompany it with music and song, and then in the splendor of a great fire we dance, eat, and drink our grief for the end of irreplaceable love. And then our friend, Lady Death, disguises herself as the most beautiful of the goddesses, takes us by the arm, and with her unequaled affection helps our grief to consume us slowly, and helps Coatlicue—omnipotent, present, and indivisible—to surround everything, and to devour all it creates under the glory of light, smiles and beauty, encircled by flowers as in the life-death of Frida Kahlo. It is a masterwork of the student who loved her and was loved, with all the others including the justice of the peace, and who painted one of the most beautiful works of art that ever came out of Mexico.

Despite the pathos of Rivera's judgment, made hypersensitive because of the loss of the great love of his life, the *Retrato de Frida Kahlo muerta* (*Portrait of the Dead Frida Kahlo*) by Arturo Estrada had a certain pleasing accent, or at least a not-so-gloomy one. In the painting Frida is surrounded by wildflowers, like a sleeping beauty who has found for a bed a large, flat-bottomed boat like the ones the

Uruapán natives have been building and gaudily decorating since time immemorial.

For the second of Arturo's one-man shows, held in the Salon of Mexican Painting in July of 1958, Rivera's death had kept its appointment. Therefore one of the twenty-eight tempera paintings was the *Retablo de Diego Rivera* (*Retablo of Diego Rivera*), in which the painter's body rests among pelicans in a corner of his studio, next to the gigantic judases made by Carmen Caballero, his paintings unfinished and the figures of the ancient gods seeming to bemoan his death.

Due to the fact that Rivera's last will and testament was not respected, his ashes were not mixed with Frida's, to be kept in the Coyoacán house. Guadalupe and Ruth Rivera Marín, Diego's daughters, and Emma Hurtado, his legal wife at the time of his death, refused to give him the "rest in peace" he had chosen. Why were his daughters' wishes obeyed? Because of a childish egoism, a false measure of things. Their vanity was better accommodated by knowing that their father was in the Rotunda de los Hombres Ilustres del Cementerio Civil de Dolores (Rotunda of Illustrious Men in the Civil Cemetery of Sorrows). They may have thought that with an homage imbued with a traditionalist personification of bourgeois respectability, they would impose on Rivera a posthumous personality that was not his. They justified the changes by saying that the action had a national character. Why—being as he was, thinking as he

thought, doing what he did—did Rivera not deserve the respect of the nation? If that was the question, his children would have had to invent a biography for the artist and change the content of his most important work. Because every bit of it responds wholly to an ideology which, if it existed in the posthumous homage, was in spite of the family members and the authorities who planned it and were careful to avoid a repetition of the scandal that occurred when Diego Rivera, at Frida's wake in the Palace of Fine Arts foyer, covered her casket with the flag of the Mexican Communist Party. The scandal culminated in the dismissal of the INBA (National Institute of Fine Arts) director, Andrés Iduarte, for not having prevented the communist flag from figuring in a sorrowful event taking place in an official location.

The usual quibbling unleashed at Rivera's death gave rise to many comments. It was said that Guadalupe Rivera was unwilling to disturb his political career in the Institutional Revolutionary Party; it was said that the National Institute of Fine Arts had threatened a strategy of indifference toward Rivera and his work if speakers from the Communist Party of Mexico were included in the mourning program. The authorities could use all kinds of pressures; in the hands of Diego's people, his intimates or allies, his desires should have been respected, and they ought to have carried them out, by forgetting their egotistical pettiness and by giving to love that transcendence of ideological respect that

Rivera deserved as a fighter, as an artisan of genius, and as an altruistic and overgenerous man.

Diego Rivera lived at the edge of the rules made by the society it was his lot to be living in. For him, as for García Lorca, life was not "noble or good or sacred," it was only beautiful, and an epilogue in tune with this pantheistic sentiment ought to be fire—the fire that had carbonized Frida's bones, giving them a sharp and brilliant beauty that Diego tried to imprison in a drawing. In the Civil Cemetery of Sorrows crematory, having beside him General Lázaro Cárdenas, Rivera took out of his pocket a little notebook, and with disconcerting tenderness fixed in it the dazzling appearance of Frida's skeleton embraced by the flames.

Rivera had asked his daughter Ruth—verbally and in writing—to have him cremated and to see to it that his ashes would be mixed with Frida's and put into the pot that he himself had brought to the Sorrows crematory, lovingly wrapped in a red cloth, on 14 July 1954. That day, while they were pouring the ashes of the woman who was his great friend, his great love, his great nightmare, his great anguish, his great fiesta into a pot, he said before many witnesses: "It won't take me long to join Frida; I've kept this pot for quite some time for our ashes."

That heavy old clay pot was in Coyoacán on the bed where Frida lived, painted, and died. The head of the Frida Kahlo Museum, Dolores Olmedo, ordered it taken away, because it startled the North American tourists. That bed

was in what was for many years an entrance hall, where Frida, after her amputation, asked it to be placed so that she could look at the garden Rivera created, and where the fountain's waters made some sounds, some music, gave some movement to the oppressive quiet. Diego ought to have been there beside Frida forever, among the Mexican short-haired dogs, the *retablos,* glass balls, jades, skeletons dressed as Tehuantepec women or workers, baskets, and drawers filled with drawings and various projects of hers. Diego and Frida's ashes being together would have stood watch—right there, only—over that large house, which instead of being a melancholy place ought to have changed into a museum as alive as any museum could be. Then a phrase from Frida's diary might have acquired a full and definitive meaning: "My Diego, I'm not alone; you're with me, you put me to sleep and you wake me up."

Seven

After Her Death

It would have been difficult to predict that the works of Remedios Varo and Machila Armida, Celia Calderón and Lucinda Urristi, Olga Costa and Alice Rahon, Andrea Gómez, Leonora Carrington, and Fanny Rabel could have been shown in the same gallery. But on Friday the 13 July 1956, all of them and many others—up to forty painters, sculptors, printmakers, and photographers—got together in the Lola Alvarez Bravo Gallery at 12 Amberes Street to pay homage to the greatest artist that Mexico had produced: Frida Kahlo. The opening had the air of a sad fiesta about it. It was festive because Frida could not be brought to mind without celebrating her, and a sad occasion because most of

the people united there—writers, actors, dancers, scientists, painters—were friends who had loved and admired her.

Hanging in a special hall were four of Frida's paintings that had not figured in her only one-woman show in Mexico, which also took place in that same gallery. To place them in the usual environment of their creator, the paintings were surrounded by judases, skulls, idols, *retablos,* and paper cutouts. In the midst of the whole, there was the *Quebrada de Acapulco* (*Acapulco Ravine*), an archeological fantasy that Rivera had painted in the Acapulco house of Dolores Olmedo on July 7, when Frida had just turned forty-nine (her true age).

On 13 July 1956, there was talk of Frida. Doctor Paula Gómez Alonso referred to her courage and capacity for love. Andrés Henestrosa read a description of Frida's house, written by Carlos Pellicer and then, filled with emotion, he reminisced about the 1953 opening. The Venezuelan poet Carlos Augusto León read a criticism by Luis Cardoza y Aragón, and finally the actress Rosaura Revueltas read a few paragraphs from Frida's diary, that intimate book in which she wrote in a way that intensely resembled herself, a book that was a mirror rather than a confession. Frida did not reveal any secrets at all there; she really sought to reflect herself in order to capture her image, elusive even for her.

Like Franz Kafka, Frida could write in her diary: "Frankly hopeless because of my body and because of the future waiting for me with this body." But with her peculiar spiritual density, she preferred to say things like these:

"What would I do without the absurd and fleeting? (I've understood dialectical materialism for many years.)

"Changes and struggles disconcert and terrify us because they're constant and certain."

"Anguish and pain—pleasure and death—are only a process for existing. The revolutionary struggle in this process is an open door to intelligence."

As usually occurs in homages, promises were made that were never kept.

All the artists were requested to present projects for building a memorial to Frida in the Coyoacán house. That memorial never materialized.

The organizing group—of artists, friends and representatives from the Democratic Union of Mexican Women—planned to establish an exhibit of women's painting—for native-born Mexicans as well as foreign residents of the country—on those same dates every year. In every exhibit a work would be selected to be preserved in the Frida Kahlo Museum. Neither the memorial to honor her nor the hall for women painters ever came into being in the Frida Kahlo Museum.

When everyone had left the Lola Alvarez Bravo Gallery, I asked Machila Armida what meaning she gave to the things locked up in a glass box with neodadaist insolence. Machila said: "They are Frida's ashes, the birds that come to see and are weeping; it is her immortal heart. A child is coming from its veins and Frida is finally becoming a star."

Source Note

This book is based on the following works previously pub-
lished by the author:

"Conversaciones chilenas con el gran mejicano Diego Rivera,"
 La Prensa, Buenos Aires, Argentina, 24 May 1953.
"Frida Kahlo, artista de genio," *La Prensa,* Buenos Aires, Ar-
 gentina, 12 July 1953.
"Frida Kahlo en la pintura y el amor de Diego Rivera," *Eva,*
 Santiago de Chile, 1953.
"Los zumbidos," *El Occidental,* Guadalajara, Jalisco, Mexico,
 11 October 1953.
"Fragmentos para una vida de Frida Kahlo," in "México en la

Cultura," supplement to *Novedades,* Mexico City, 7 March 1954.

"Arturo Estrada frente a sus criticos y a sus maestros," in "México en la Cultura," supplement to *Novedades,* Mexico City, 10 July 1955.

"Carmen Caballero, fabricante de muerte," in "México en la Cultura," supplement to *Novedades,* Mexico City, 31 July 1955.

"Frida Kahlo en el segundo aniversario de su muerte," "México en la Cultura," supplement to *Novedades,* Mexico City, 15 July 1956.

"Primer Salón Frida Kahlo," in "México en la Cultura," supplement to *Novedades,* Mexico City, 22 July 1956.

"Tenía derecho a su muerte," *Paralelo,* Mexico City, December 1957.

"El Museo Frida Kahlo en el quinto aniversario de su muerte," in "Papel Literario," supplement to *El Nacional,* Caracas, Venezuela, 16 July 1959.

"Frida Kahlo, maestra de pintura," in "Diorama de la Cultura," supplement to *Excélsior,* Mexico City, August, 1960.

Arturo Estrada y sus caminos en el arte mexicano, pamphlet of the Instituto Nacional de la Juventud Mexicana, Mexico City, 1961.

"Murió Cristina Kahlo," *Política,* Mexico City, 15 February 1964.

"Epoca moderna y contemporanea," in *Historia general del arte mexicano,* Editorial Hermes, 1964.

"Frida Kahlo en los Estados Unidos," *Política,* Mexico City, 1 November 1965.

"Surrealismo historico," *Política,* Mexico City, 1 January 1967.

"Cuando los judas no dan color," "Magazine Dominical," in *Excélsior,* 2 March 1969.

"Frida Kahlo en sus sesenta años: fantasía y realidad," *Calli,* no. 47, March–April 1970.

"¿Fue Frida Kahlo una pintura surrealista?," in "La Cultura en México," supplement to *Siempre,* no. 893, Mexico City, 5 August 1970.

"Frida Kahlo a veinte años de su muerte," in "Diorama de la Cultura," supplement to *Excélsior,* Mexico City, 14 July 1974.

"Die Kulturpolitik der Cardenas-Regierung: 1934–1940," catalog article for the exhibit "Kunst der Mexicanischen Revolution—Legende und Wirklichkeit," organized by *Die neue Gesellschaft für bildende Kunst,* in West Berlin, November–December 1974.

"Revive el interés por Frida Kahlo," Nonotza-IBM, no. 12, October–November–December 1977.

Frida Kahlo: crónicas, testimonios y aproximaciones, Ediciones de Cultura Popular, Mexico City, 1977.

"Frida Kahlo y los veneros de su pintura," in *La Semana de Bellas Artes,* supplement of the Instituto Nacional de Bellas Artes, no. 2, 13 December 1977.

"Evolución del autoretrato," *Proceso,* no. 65, 30 January 1978.

Frida Kahlo, Verlag Neue Kritik, Frankfurt, Federal Republic of Germany, 1980.

"La verdadera edad de Frida Kahlo," *Proceso,* 13 July 1981.

"El Moisés de Freud en versión de Frida Kahlo," *Proceso,* 30 August 1982.

Index

abrazo de amor entre el Universo, la Tierra, yo y Diego, El,
 22–23, 66, 137
Acapulco Ravine (Rivera), 206
Almazán, Andrew, 6
Alvarez Bravo, Lola, 154; illus., 82
Amamos la paz y el mundo de cabeza por la belleza, 195, 198
A mi no me queda ya ni la menor esperanza, 23, 179
Amor, Guadalupe, 195
Anahuacalli museum, 158, 172
Anguiano, Raúl, 108
Arbol de la esperanza mántente firme, 23
Arbol genealogico, 100, 160
Arenal, Luis, 108

Armida, Machila, 205; quoted, 207

arsenal, El (Rivera), 24

art: capitalism and, 120–21, 128; Lenin and, 181; Mexican government and, 103–9, 111–13, 116, 188; Mexican native, 94, 99, 123, 131, 161, 163, 165–73; pre-Columbian, 170; teaching of, 177–86, 190–99

artists: futurist, 90–94; political action and, 128; surrealist, 94–99; after World War II, 120. *See also names of artists*

artists, Mexican: Breton and, 122–23; exhibitions of, 98–100, 134–37; in Frida Kahlo Museum, 164–73; futurism and, 90, 119–20; political protest and, 103–9, 117–19; *retablos* and, 131; Rivera and, 163; Society for Encouragement of Creative Arts and, 135–37; as teachers, 178, 184; women, 89, 131–32. *See also names of individuals*

Atl, Dr., 40, 90, 176

Azuela, Salvador, quoted, 100–102

Balla, Giacomo, 93

Ballad of the Revolution (Rivera), 24, 114

Bank of Mexico Trust, 176

Begun, Henriette, 11–18

Boccioni, Umberto, 93, 119

Boletin del Seminario de Cultura Mexicano, 124–25

Boytler, Arcady, 76–78; illus., 83

Boytler, Lina, 76–77

Bravo, Alvarez, 99

Breton, André, 2, 69, 71, 127–28; Frida Kahlo and, 95–96; "Frida Kahlo de Rivera," 7, 122–23; illus., 82; *Man-*

ifesto of Surrealism, 95, 123, 125–26; *Le surréalisme et la peinture,* 122–23, 128–29

Breton, Jacqueline, 122; (illus.), 82

Bride Astonished at Seeing an Open Life, The, 180

Broken Column, The, 23, 179

Bulletin of the Mexican Seminary of Culture, 124–25

Bustos, Arturo García, 181, 187, 195

Caballero Sevilla, Carmen, 164–73; illus., 85

Cabeza idolo monstruo, illus., 85

Calavera catrina (Posada), 115

Calderón, Antonio (maternal grandfather), 1, 30, 33

Calderón, Celia, 205

Calderón, Pedro, 46

Calderón Gonzalez, Isabel (grandmother), 1, 12, 30, 32

Calderón y Gonzalez, Matilde (mother), 1, 11–12, 22, 30–31, 35–36, 52, 38–39, 43–44, 160

California School of Fine Arts, mural at, 121

Calles, Plutarco Elías, 113; quoted, 116

Campos, Isabel, 90; letters to, 44–45, 61–66

Campos, Marco Antonio, 90

capitalism, art and, 120–21, 128

Cárdenas, Lázaro, 117, 203; arts and, 104, 107–9, 111–13, 116; quoted, 108

Cardoza y Aragón, Luis, 206; illus., 82

Carrà, Carlo, 93

Carrillo, Lilia, 93

Carrington, Leonora, 205

Casa de la mujer Ana María Hernández, 198

Casa de la mujer Josefa Ortiz de Domínguez, 198

Castellanos, Julio, 3, 100

Castro, Rosa, quoted, 195–97

Chávez, Carlos, quoted, 112

Churches of Mexico, The, 40, 176

Civil Cemetery of Sorrows, 201, 203

classicism, 170, 183

Clausell, Joaquín, 175

Clave, 103–6

columna rota, La, 23, 179

Communist Manifesto (Marx and Engels), 104

Communist party, 119; Frida Kahlo and, 31, 78; Rivera and, 6

Communist Party of Mexico, 202

Communist Youth, 119

Continental Congress of Culture, 129–30

Corrido de la Revolución, El (Rivera), 24, 114

Costa, Olga, 89, 205

"court of miracles," 3

Coyoacán, house at, 116, 157–64, 196–97; classes at, 180–82, 190–91; illus., 86–87; Rivera and, 161–64, 203–4; Trotsky and, 122, 161–62. *See also* Frida Kahlo Museum

cristeros, 109

cubism, 183

Cutting My Hair with a Pair of Scissors, 23

Dalí, Salvador, 126–27

dance, Mexican, 111–12

del Rio, Dolores, 83

Democratic Union of Mexican Women, 207
Department of Creative Arts, 3, 188
Department of Social Action Art Gallery, exhibitions at,
 99–102
Día, El, 195–97
Díaz Infante, Dr., 46
Diego and Frida, 5
Diego and I, 179
Diego en mi pensamiento, 179
Diego in My Thoughts, 179
Diego y Frida, 5
Diego y yo, 179
dos Fridas, Las, 23, 99
Dream of a Sunday Afternoon on the Alameda (Rivera),
 114–15, 145
Duchamp, Marcel, 71

Elegant Skull (Posada), 115
Eloesser, Leo, 14, 16
Engels, Friedrich, 104
En nombre de Cristo, 109
España de Franco, La, 108–9
Estrada, Arturo, 181, 187, 195; *Retablo de Diego Rivera,*
 201; *Retrato de Frida Kahlo muerta,* 199–201
Excelsior, 118, 192

fascism, 109, 117–18
fauvism, 183
Félix, María, 195
Fernández, Fernando, 11

Fernández Ledesma, Gabriel, 3, 134

Ferrel, José, 103

Ferreto, Judith, 79

First Futurist Manifesto (1909), 90

For Myself There Is Not the Slightest Hope Left, 23, 179

"Forty-five Self-Portraits by Mexican Painters," 134–35

Fourth International, 6

Franco's Spain, 108–9

Frank, Waldo, 110; quoted, 111

Free Art Exhibition, 187

Freud, Sigmund, 18, 71–76; *Moses,* 71–76

"Frida Kahlo de Rivera" (Breton), 7, 122–23

Frida Kahlo Museum, 78, 116, 160, 172–76, 203–4, 207.
 See also Coyoacán, house at

"Frida Kahlo y el arte mexicano" (Rivera), 124–25

futurism, 90–94, 119–20

Futuro, 117–18

Gallery of Mexican Art, 95

Galván, Saldana, 199

Gamboa, Fernando, 137

Gamboa, Susana, 137

Gaya, Ramón, quoted, 96–98

Genealogical Tree, 100, 160

Germany, 108–9, 117

Glusker, David, 15, 18, 79

Goeritz, Mathias, 158

Gómez, Andrea, 205

Gómez Alonso, Paula, 206

Gómez Arias, Alejandro, letters to, 13, 44–60, 67–69, 77

Gómez Arias, Alicia, letters to, 48–49, 58
Gonzalez, Gea, 17
Gonzales Camarena, Jorge, 173
Greco, El. *See* Theotokópoulos, Doménikos
Guardia, Miguel, quoted, 2
Guerrero, Xavier, 108

Hall of Mexican Creative Art, 137
Henestrosa, Andrés, 206
Hernández, Paco, 40
Hitler, Adolf, 108
"Homage to Guillermo Kahlo," 32–35
Hurtado, Emma, 201

Iduarte, Andrés, 202
Iglesias de México, Las, 40, 176
impressionism, 183
INBA. *See* National Institute of Fine Arts
Inés Amor gallery, 96
Institute of Anthropology and History, 35
International Exhibition of Surrealism, 95–98
International Federation of Independent Revolutionary
 Art, 127–28
International Golden Gate Exposition, 115
International Red Cross, 119
In the Name of Christ, 109
Italy, 117
Izquierdo, María, 89

Judases, 163, 165–67, 172

Julien Levy gallery, Frida Kahlo's show at, 66–67, 69

Kahlo, Adriana (sister), 43, 160–61
Kahlo, Cristina (sister), 22, 31, 36–37, 39, 42, 49, 65, 113,
 115–16, 160–61
Kahlo, Frida: accident of, 42–47; arrested, 71; artistic
 style of, 5–6, 18–20, 23, 66–67, 72–76, 80, 94, 129, 132–
 33, 184–85; artistic taste of, 69–70; attempted suicide
 of, 4; birthdate of, 1, 11–12, 89–90, 160; Caballero
 Sevilla and, 166–67, 173; childhood of, 22, 35–41; death
 mask of, 88; death of, 4, 20, 199–201, 203; diary of, 21–
 22, 25–28, 79–80, 94, 204, 206–7; divorce of, 25, 71,
 162; dress of, 23–25, 123, 134, 180; education of, 10–11,
 36, 50, 58; exhibitions of, 66–67, 69, 71, 89, 99–100, 130,
 134–35, 154–55; family history of, 30–32; and family
 members, 11–12; illus., 81–84, 86, 88; imagination of,
 37–38, 47, 68, 124–25, 127, 132–33; Cristina Kahlo and,
 115–16; letters of, 44–71, 77–78, 174; literary tastes of,
 49–50, 52, 59; marriage of, 2, 13, 20–21, 60–61, 161;
 medical history of, 2, 11–18, 38, 53–54; medical treat-
 ment of, 50–52, 53–59, 77–79, 196; palette of, 184–85;
 personality of, 9–10, 24, 123, 132–34, 162, 178–79; pets
 of, 80, 158; philosophy of, 18, 21–22, 24, 44, 52–53, 67,
 94, 206–7; poetry of, 28, 41–42, 76, 154–55; political be-
 liefs of, 6–7, 24, 30–31, 39–40, 78, 103, 106, 181, 184;
 "Portrait of Diego," 137–54; possessions of, 157–59,
 163–64, 173–75, 196–97; pregnancies of, 13–15; pro-
 posed memorial to, 207; quoted, 3–4, 19, 30–33, 35–44,
 61, 66–67, 71–76, 78, 94, 134–35, 184, 197; "Recuerdo,"
 41–42; religion and, 36–37, 39; remarriage of, 71;

Rivera and, 2–7, 24–28, 60–61, 66, 70–71, 79, 124–25, 129–34, 158–59, 202–4; in Rivera's paintings, 4–5, 24, 113–15; suicide and, 79; surrealism and, 7, 94–95, 123–27, 197 98; as teacher, 178–86, 190–99; television documentary on, 89–90

Kahlo, Frida, paintings by: *El abrazo de amor entre el Universo, la Tierra, yo y Diego,* 22–23, 66, 137; *A mi no me queda ya ni la menor esperanza,* 23, 179; *Arbol de la esperanza mántente firme,* 23; *Arbol genealógico,* 100, 160; *La columna rota,* 23, 179; *Cortándome el pelo con unas tijeras,* 23; *Diego en mi pensamiento,* 179; *Diego y Frida,* 5; *Diego y yo,* 179; *Las dos Fridas,* 23, 99; *Lo que vi en el agua,* 121; *La mesa herida,* 99; *Mi nadriza y yo,* 22, 66; *Mis abuelos, mis padres y yo,* 160; *Moisés,* 71–76, 180; murals, 67–68; *La novia que se espanta al ver la vida abierta,* 180; *Paz en la tierra para que la ciencia marxista salve a los inválidos,* 67; *Pensando en la muerte,* 179; portraits, 53, 56–57, 66, 179; *Raices,* 23; self-portraits, 5, 22–23, 67, 80, 121, 126–27, 129, 134, 179; *El surrealismo es la magica sorpresa de encontrar un leon dentro,* 180; *Tehuana,* 134, 179; *El venado herido,* 76

Kahlo, Guillermo (father), 1, 11, 31–36, 43, 52–53; as photographer, 10, 39–40, 56–57, 175–76

Kahlo, Jacobo Enrique (grandfather), 1, 12

Kahlo, Margarita (half-sister), 32, 160

Kahlo, María Luisa (half-sister), 32, 160; quoted, 37

Kahlo, Matilde (sister), 38–40, 43–44, 57, 65, 160–61

Kahlo, Wilhelm, 160

Kandinsky, Vasily, 71

Kaufmann, Enriqueta (grandmother), 1

La Esmeralda, 177–79, 184–85, 199
La Rosita, murals at, 191–95, 199
Lavín, José Domingo, 71
League of Revolutionary Artists and Writers (LRAW),
 108–11
LEAR, 110–12
Lenin, Vladimir, 113; quoted, 181
León, Carlo Augusto, 206
Levy, Julien, 69
Lewinsohn, Sam A., 70
Life, 69
Limantour, José Ives, 34
Lira, Miguel N., 100
Lola Alvarez Bravo Gallery, tribute to Frida Kahlo at,
 205–7
Lombardo Toledano, Vicente, 117
López Mateos, Adolfo, 107
Lo que vi en el agua, 121
"Los Fridos," 180–82, 184–87, 195, 198–99
*Love Embrace between the Universe, the Earth, Diego and
 Me,* 22–23, 66, 137
LRAW. *See* League of Revolutionary Artists and Writers

Magaña, Mardoño, 163
Mancisidor, José, 129
Manifesto of Futurist Painters, 90–94, 120
Manifesto of Surrealism (Breton), 95, 123, 125–26
Manolo, 158
Marín, Federico, 16
Marín, J. de Jesús, 14

Marín, Lupe, illus., 82

Marinello, Juan, quoted, 110–11

Marinetti, Felipe Tomás, quoted, 90–94

Martí, José, 111, 114

Marx, Karl, 18, 67, 104

Maugard, Adolfo Best, illus., 83

"Memory," 41–42

Méndez, Leopoldo, 108

Mercader, Ramón, 162

Mérida, Carlos, 111–12

mesa herida, La, 99

Mexican League of Artists and Writers, 110–12

Mexican Revolution, 30–31; murals and, 113–14, 116

Mexican Union of Electricians, mural for, 119

México, 33

Mexico City Central Airport, murals in, 103

México de hoy y del mañana, El (Rivera), 113, 116

Mexico Today and Tomorrow, 113, 116

Michel, Concha, 20

Mi nadriza y yo, 22, 66

Mino, Isaura, 79

Miranda, Santos, 172

Mis abuelos, mis padres y yo, 160

Moisés, 71–76, 180

Monroy, Guillermo, 181, 187; quoted, 194

Monterde, Francisco, quoted, 32–33

Moore, Henry, 168

Moro, Cesar, 95

Moses, 71–76, 180

Moses (Freud), 71–76

Mújica, Francisco, 104, 106
muralists, 10, 191–97. *See also names of individuals*
murals: government policy and, 103–7; Frida Kahlo and,
 67–68, 190–99; La Rosita, 191–95, 199; O'Gorman's,
 103–6, 108; Orozco's, 113; Rivera's, 4–6, 24, 61, 113–16,
 121. *See also names of artists; names of paintings*
music, 112
My Grandparents, My Parents and I, 160
My Wetnurse and I, 22, 66

Nabakowsky, Gislind, 89
narcissism, 121
National Autonomous University, 100–102
National Congress of Artists and Writers, 110–12
National Institute of Anthropology, 34
National Institute of Fine Arts (INBA), 3, 89, 134, 137,
 202
National Institute of Mexican Youth, murals at, 107
National Museum of Creative Arts, 135
National Palace, murals at, 113
National Preparatory School, 10
National School of Creative Arts, 175
National School of Painting and Sculpture, 2
National Welfare Administration, 35
naturalism, 183
Navarro, Armando, 79
Nazism, 6
Nicolay, Peter, 90
Nightmare of War, Dream of Peace (Rivera), 114
North American Institute of Mexico, 32

novia que se espanta al ver la vida abierta, La, 180

O'Gorman, Juan, 191–92; murals of, 103–6, 108; Rivera
 and, 161, 163; self-portraits of, 121–22
Olmedo, Dolores, 203, 206
Open Air School of Painting, 163
Open Air Schools, 193
Orozco, José Clemente, 109, 175, 192; murals of, 113, 191

Paalen, Alice. *See* Rahon, Alice
Paalen, Wolfgang, 95, 128
Palace of Fine Arts: exhibitions at, 113, 134–35, 185–86;
 Frida Kahlo's wake at, 202; murals at, 113
Parrés, Ramón, 79
Paz en la tierra para que la ciencia marxista salve a los inválidos, 67
Peace on Earth So That Marxist Science May Save the Sick,
 67
Pellicer, Carlos, 174–75, 206
Pensando en la muerte, 179
Pesadilla de guerra, sueño de paz (Rivera), 114
Phillip, Jackson, 66
Picasso, Pablo, 71, 170; quoted, 130
Piedrasanta, Gregorio, 164
Pinedo Kahlo, Antonio, 113–14, 161
Pinedo Kahlo, Isolda, 113–14, 161
Popular Army of the Republic, 117
Portrait of the Bourgeoisie (Siqueiros and Renau), 119
Portrait of the Dead Frida Kahlo (Estrada), 199–201
Posada, José Guadalupe, 31, 171; *Calavera catrina,* 115

Posada del Sol hotel, murals at, 199
Pratt, Dr., 14–15
Prensa, La, 61
press, Mexican: political art and, 188–89; Rivera and, 145;
 Spain and, 117–18. *See also names of publications*
Proenza, Teresa (Tere), 79
pulquería painting, 190–97

Quebrada de Acapulco (Rivera), 206
Quienes nos explotan y como nos explotan (Estrada, Bustos
 and Monroy), 187–88

Rabel, Fanny, 181, 205
Rahon, Alice, 99, 205
Raices, 23
realism, 184
"Recuerdo," 41–42
religion: Mexican art and, 188–89; Mexican government
 and, 109; in Rivera's painting, 114
Remedios. *See* Varo, Remedios
Renau, José, 119
Retablo de Diego Rivera (Estrada), 201
retablos, 94, 131, 163, 196–97, 204
Retrato de Burguesia (Siqueiros and Renau), 119
Retrato de Frida Kahlo muerta (Estrada), 199–201
Revueltas, Rosaura, 206
Rivera, Diego: appearance of, 138–39; Caballero Sevilla
 and, 166–73; collections of, 145, 147–49, 158, 161, 163–
 64; Coyoacán house and, 161–63; death of, 201–3; di-
 vorce of, 25, 71, 162; health of, 146–47; honored by

National Institute of Fine Arts, 137; illus., 82, 84, 86;
Frida Kahlo and, 2–7, 24–28, 60–61, 66, 70–71, 79,
124–25, 129–34, 158–59, 181–82, 202–4; Frida Kahlo's
account of, 137–54; in Frida Kahlo's paintings, 5–6,
22–23; "Frida Kahlo y el arte mexicano," 124–25;
lithographs of, 114; marriage of, 2, 20–21, 60–61, 161;
personality of, 139–54, 182–83, 203; political beliefs of,
6, 103, 106, 128, 141–43, 152, 188–89, 202–3; *pulquería*
painting and, 191; quoted, 7, 66, 70, 130–34, 158, 181,
188–89, 199–200, 203; remarriage of, 71; self-portraits
of, 121; as teacher, 178, 182, 193; Trotsky and, 122,
161–62; views on art, 167–72, 182–84; wealth of, 146–
47
Rivera, Diego, paintings by: *El arsenal,* 24; attacks on,
145; *Corrido de la Revolución,* 24, 114; *El México de hoy
y del mañana,* 113, 116; murals, 4–6, 61, 113–16, 121,
191; *Pesadilla de guerra, sueño de paz* (Rivera), 114;
Quebrada de Acapulco, 206; *Sueño de una tarde domeni-
cal en la Alameda Central,* 114–15, 145
Rivera Marín, Guadalupe, 201–2
Rivera Marín, Ruth, 201, 203
Robusti, Jacopo (Tintoretto), 169
Rockefeller, Nelson, 6, 113
Rockefeller Center, mural at, 6, 113
Rolland, Modesto, 103–6
Romance, 96–98
romanticism, 95, 120–21, 169
Roots, 23
Rotunda de los Hombres Illustres del Cementerio Civil
de Dolores, 201

Ruiz, Antonio M., 193; quoted, 177–78

Safa, Morillo, 66
Salinas, General L., 103–4
Salon of Mexican Painting, exhibition at, 199–201
San Angel Inn, 122, 161
San Pablo Tepetlapa, Anahuacalli museum at, 158, 172
School of Painting and Sculpture, 177, 185. *See also* La
 Esmeralda
School of Wood Carving, 177
Secretariat of Health, murals at, 115
Secretariat of Public Education, 177, 188; murals at, 4, 24,
 107, 114; publications of, 109
Secretariat of the Treasury and Public Credit, 35
Sedova, Natalia, 84
self-portraits: art and, 121–22; Frida Kahlo's, 5, 22–23, 67,
 80, 121, 126–27, 129, 134, 179; by Mexican artists, 89,
 134; O'Gorman's, 121–22; Rivera's, 121
Severini, Gino, 93
Siqueiros, David Alfaro, 6, 71, 90, 162; quoted, 20, 117–20
social expressionism, 108–9
Society for the Encouragement of Creative Arts, 135–37
Soviet Union, 6–7
Spain, 108–9, 111, 117–18
Spanish Civil War, 109, 117–18
Stalinists, U.S., 6
stridentists, 90
students; exhibitions of, 185–88; Frida Kahlo's, 180–82,
 184–87; murals and, 190–99; political art and, 186–90
Sueño de una tarde domenical en la Alameda Central
 (Rivera), 114, 145

surrealism, 95–98, 123, 125–26; Frida Kahlo and, 7, 94–
95, 123–27, 197–98
Surrealism and Painting (Breton), 7, 122–23, 128–29
surréalisme et la peinture, Le (Breton), 7, 122–23, 128–29
Surrealism Is the Magic Surprise of Meeting a Lion, 180
*surrealismo es la magica sorpresa de encontrar un leon den-
tro, El,* 180

Tamayo, Rufino, 128–29
Technical Manifesto of Futurist Painting, 90
Tehuana, 134, 179
Tehuantepec Woman, The, 134, 179
Theotokópoulos, Doménikos (El Greco), 169
Thinking of Death, 179
Those Who Exploit Us and How They Exploit Us (Estrada,
Bustos and Monroy), 187–88
Tintoretto. *See* Robusti, Jacopo
Tirado, Ortiz, 13
Toussaint, Manuel, 176
Tree of Hope, Stand Fast, 23
Tricolor, 33
Trotsky, Leon, 6, 71, 128, 162; illus., 84; Rivera and, 122,
161–62
Trotsky, Natalia, 162
Trotskyites, 6
Two Fridas, The, 23, 99

Union of Young Revolutionary Artists, 186–90
Universal Ilustrado, El, 41
University, 100–102

Urristi, Lucinda, 205

Varo, Remedios, 99, 205
Velasco, José María, 175
Velázquez, Diego, 169–70
venado herido, El, 76
Villaseñor, Isabel, 89
. Villegas, Cosío, 17
Vogue, 69

We Madly Love Peace and the World for Their Beauty, 195,
 198
What I Saw in the Water, 121
Wilson, Philip, 18
Workshop of Popular Graphics, 108
Wounded Deer, The, 76
Wounded Table, 99

Xólotl (Frida Kahlo's dog), 158

Young Communists. 31

Zamora, Adolfo, 103
Zapata, Emiliano, 30–31
Zevada, Ricardo J., 116
Zimbrón, Velasco, 16–17
Zúñiga, Lupita, 79